Frank Sinatra

The Family Album

Little, Brown and Company
Hachette Book Group USA
237 Park Avenue, New York, NY 10017
Visit our Web site at www.HachetteBookGroupUSA.com

First Edition: November 2007

ISBN 0-316-00349-2 / 978-0-316-00349-0
LCCN 2007927145

10 9 8 7 6 5 4 3 2 1

Printed in China

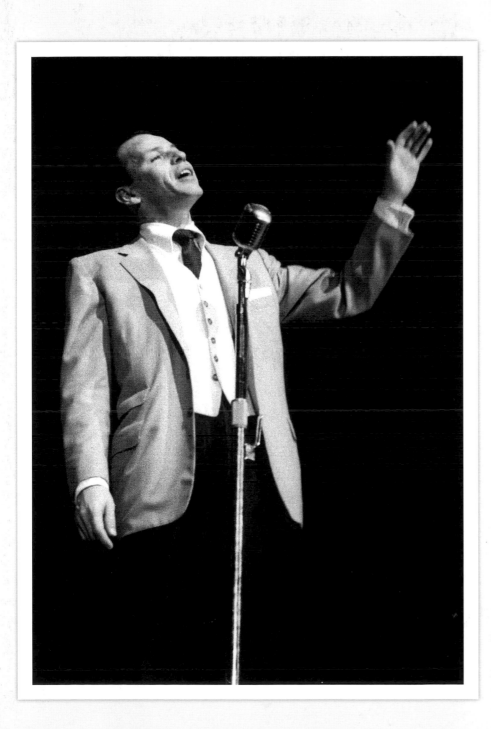

Frank Sinatra

The Family Album

by Charles Pignone

Little, Brown and Company
New York Boston London

Author's Note

Photos are one-dimensional; Frank Sinatra was not.

The Sinatra family has generously opened their photo archives to give us a glimpse of both the personal and professional sides of Sinatra that few have seen. Millions of words have been written about the artist and the man, but they can never capture his true spirit, style, and essence. Hopefully, these photos and text will convey what an extraordinary life he led.

During the last decade of his career, I had the good fortune to attend most of Frank Sinatra's live performances. The memories I have from this period will last a lifetime. As Angie Dickinson recently told me, "We're always thinking about Frank . . . life's not the same without him." It sure isn't.

—Charles Pignone

Dedication

This book is dedicated, with love, to Al Viola. His warmth, grace, and generosity will forever be remembered.

The first time I saw Al was when he appeared in the movie *Romance on the High Seas*, as part of the Page Cavanaugh Trio. They played and sang with Doris Day and I fell in love with the song, "Put 'Em in a Box." Al's mellow picking and strumming, plus his cool singing voice, added so much to the early P.C. Trio. He played with Page for years after that, and I was fortunate to see them perform together again a few years ago. Same smiles and same sounds.

The best gift he gave my dad on a stage, besides always being musically perfect, was that he knew when to get out of the way and when to fill in. Their duets were breathtaking, and Dad always introduced him to the audiences with great pride.

Al's mellow tones would be part of my life growing up and as an adult. Come to think of it, I can't really remember my life when Al wasn't in it. He was brilliant onstage and in the studio. When my dad's last recording of "Silent Night" was sweetened by a Johnny Mandel string arrangement, Al was there.

The last time I saw Al Viola, he was giving a eulogy at Bill Miller's memorial. I realized then that he was really the last one left of the old guard, my dad's musicians, whom I have known all my life.

Yes, Al was always there and now he's gone.

I'll miss him, but I will treasure my memories and be eternally grateful we still have his music.

—Nancy Sinatra Jr.

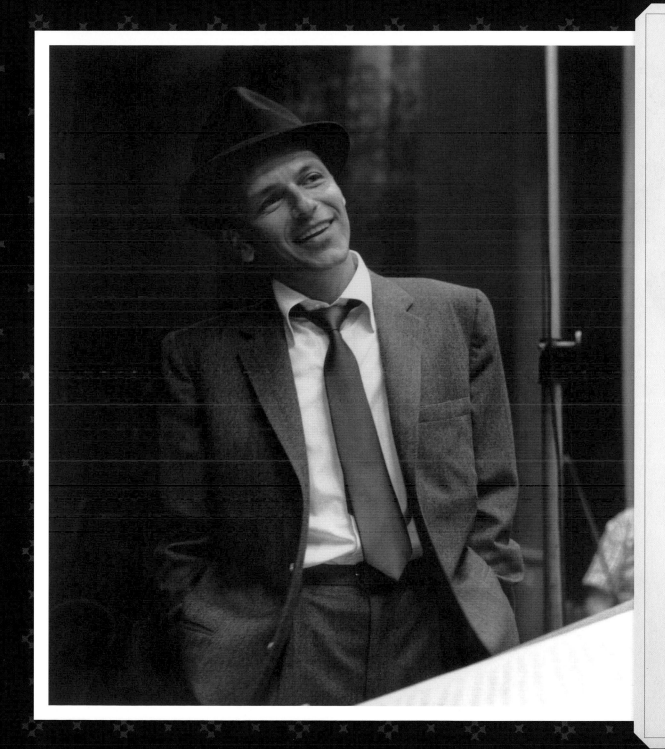

INTRODUCTION

Close your eyes and think of your most wonderful dream. Maybe it's the dream that you had when you were young, and life seemed endless; or maybe it's the dream you have later in your life when it's quiet at night and you finally have time to think. Think of the dream that could get you through anything. The dream that, one day, would cease to be a dream—one day, it would become a reality.

My grandfather had such a dream: He wanted to be a singer, and to live a life through music. He wanted to make all of our lives better through that music. He wanted to live large and see the world. He wanted to love and help people. My grandfather's life exceeded his dreams, and this is a rare gift. He was someone who changed the world. Changing the world came with a price, as those whose lives become bigger than their dreams will tell you. When we had time to spend together, he was so happy—he loved to be with his family. Unfortunately, those times were few and far between. He worked so hard to make all of our dreams come true, and I will never be able to thank him for all that he has done for me. He was always there, even when he wasn't.

As you have moved through your life, whether you are young or old, I bet my grandfather's voice was there, drifting in the background of your most precious moments. Perhaps it was your wedding, or your graduation. Your first kiss? Your first heartbreak? It could have been a lonely dinner for one, or just a passing moment of sadness. His voice is everywhere. When I hear it coming through the speakers at a shopping mall at Christmas time, or at Yankee Stadium, I feel a little sad. Then I smile because it is wonderful to be reminded of someone who you love, and someone who loved you with all of their heart.

I was not around for the majority of his life, so I suppose my memories of my grandfather will be different from those of people who knew him before 1976. What I know is that he was loving, funny, hardworking, a bit moody, and amazingly neat. He loved to sing—he did it all the time in private—and he loved to paint. The art studio was my favorite place to be in his house in Palm Springs. All of his paint tubes were lined up and sorted by color and shade. His brushes were in jars according to size and shape, and rulers hung by the sides of the easels. Rolls of masking tape in various widths were lined up in a box. My grandpa taught me how to paint in that room, and I am happy to say that today I am a working artist. When I was in college, I gave him a painting that I did for him. He hung it on the wall in front of his bed so he could look at it all the time.

His dressing room was my second favorite place. All the clothes were lined up in perfect stacks, organized by color. His most treasured photographs were in lovely frames in rows on the countertops, and mixed in were keepsakes from the trips he had been on and gifts he had received from my sister and me over the years. He had a tray of colognes, and drawers full of the most beautiful handkerchiefs and ties in all the colors of the rainbow. He always had cherry Life Savers, and Wrigley's PK chewing gum. The room smelled of him: like Yardley's lavender soap, and Aqua Velva. As a young kid, I would sneak in to his dressing room when everyone was at dinner. I loved to be in there, and to mess with his cuff links. He had a lot of those.

His house in Palm Springs was exactly how he wanted it: It was always warm, and it was decorated with accents of his favorite color, orange. The house was very comfortable, and it was never lonely. My grandpa ate breakfast in the den, and did the *New York Times* crossword puzzle in pen. He was a creature of habit, and I liked it. I always knew where he would be at all different times of the day.

The reason I am writing all of this in the introduction is so that you will look at these pictures from a different perspective. I hope you look at them through the eyes of a granddaughter who loved her grandfather. I didn't see him as a superstar; he was Grandpa. He liked maple bars and loved to dive in the pool. He liked to watch *Jeopardy!* and play with the dogs. He loved the sun and had a bad temper sometimes. He wasn't very good with money, and he wanted us to succeed in life. He always said, "Stay in school, go to college, and make me proud. Finish." I did. I called him to tell him I had graduated with honors. Three days later, my Grandpa passed away.

I miss him every day, and I know that his spirit is always with me. I hope you enjoy the book, and that you look at my grandfather with new eyes.

Amanda Erlinger
February 2007

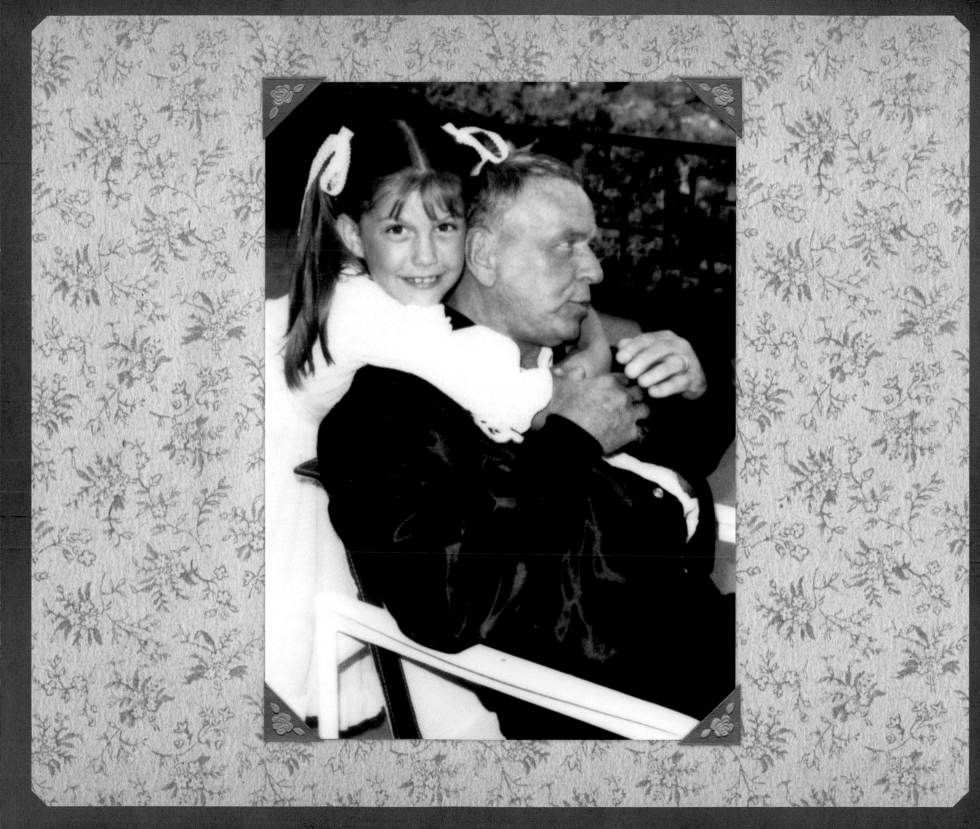

When the World Was Young

····································

1915–1939

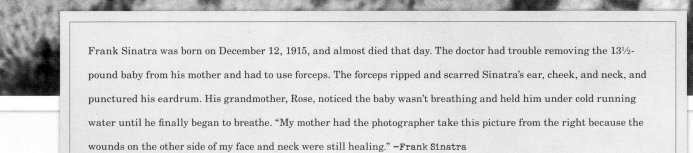

Frank Sinatra was born on December 12, 1915, and almost died that day. The doctor had trouble removing the 13½-pound baby from his mother and had to use forceps. The forceps ripped and scarred Sinatra's ear, cheek, and neck, and punctured his eardrum. His grandmother, Rose, noticed the baby wasn't breathing and held him under cold running water until he finally began to breathe. "My mother had the photographer take this picture from the right because the wounds on the other side of my face and neck were still healing." —Frank Sinatra

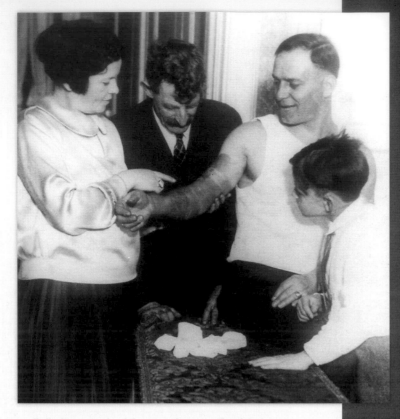

Dolly Sinatra, a local doctor, and a young Frank look at Marty Sinatra's arm, which was injured in a fire. Marty was a member of the Hoboken Fire Department at the time.

(far right) Sinatra with his bicycle on the streets of Hoboken, New Jersey, in 1928.

"Even as a young boy, Pop had a great sense of style . . . that stayed with him his entire life." —Tina Sinatra

"Frank was an immaculate dresser from the time we first met." —Nancy Sinatra Sr.

The Sinatra style was evident from the beginning.

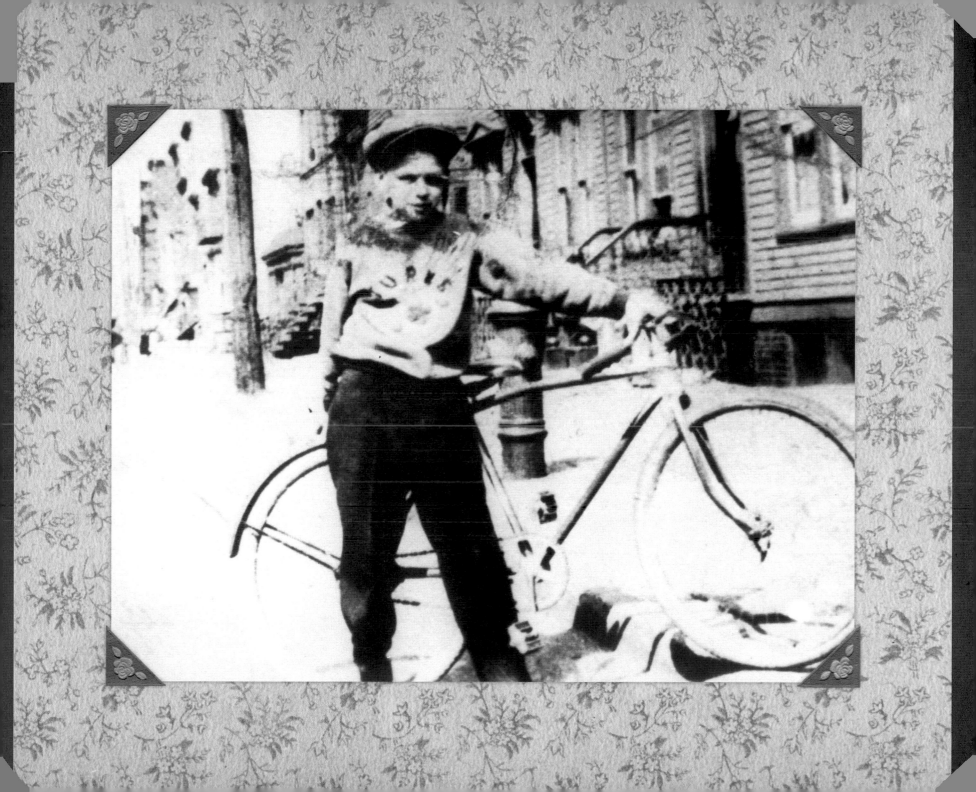

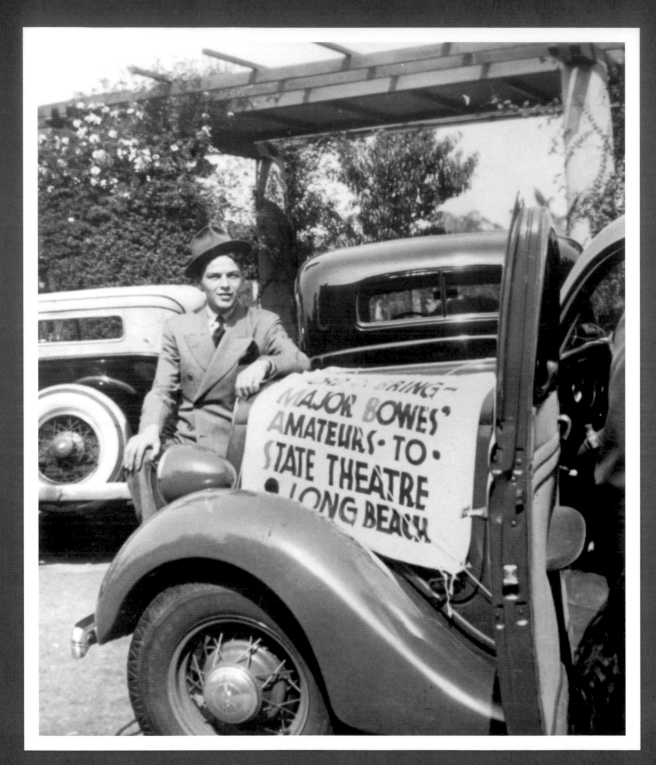

Frank in Long Beach, California, 1935

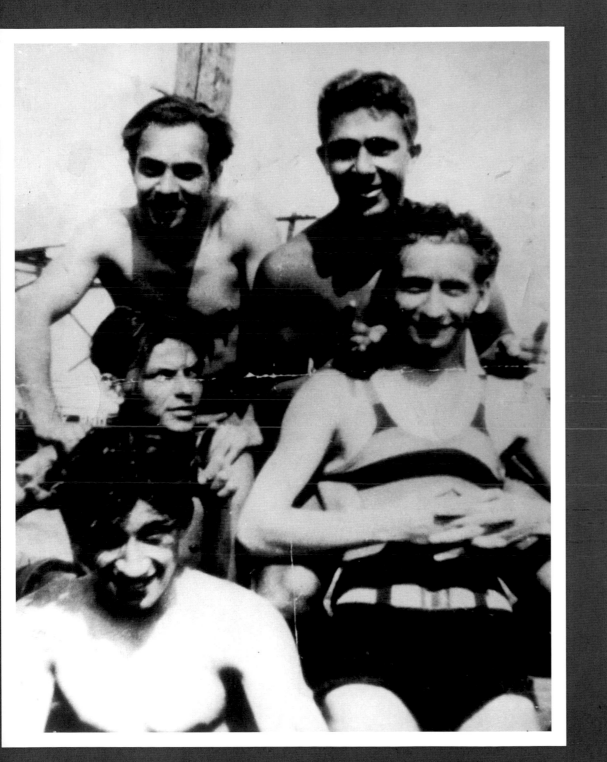

Frank (left, center) and friends at the Jersey Shore in the early 1930s.

(far left) The Hoboken Four had won first place on *Major Bowes and His Original Amateur Hour,* a hugely popular radio program, which at the time was essentially the *American Idol* of its day. The group would also become a part of the Major's touring company.

"We bought our own food, paid for our rooms and stayed at the best hotels . . . that was because outside, there was always a white banner that read 'Major Bowes' Amateurs Stopping Here.' The program was such a hit that people wanted to come and see what we looked like, like animals in a cage. We were no longer amateurs—we were getting paid. That was the first time I had ever been away and I just wanted to go home. I missed my girl and I missed my family." —Frank Sinatra

...

(left) "I love this picture of my father. I can see why my mother fell in love with him."

—Nancy Sinatra Jr.

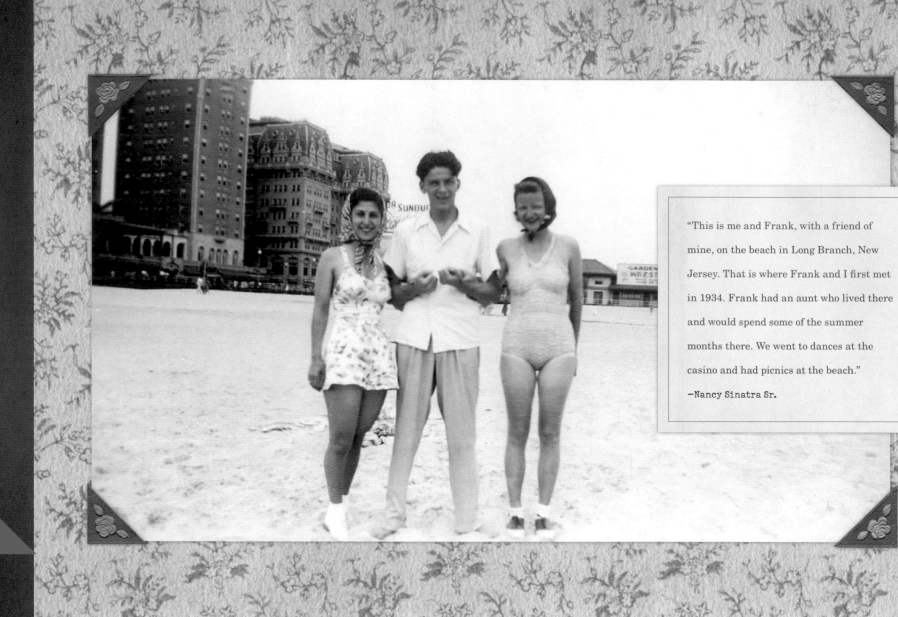

"This is me and Frank, with a friend of mine, on the beach in Long Branch, New Jersey. That is where Frank and I first met in 1934. Frank had an aunt who lived there and would spend some of the summer months there. We went to dances at the casino and had picnics at the beach."

—Nancy Sinatra Sr.

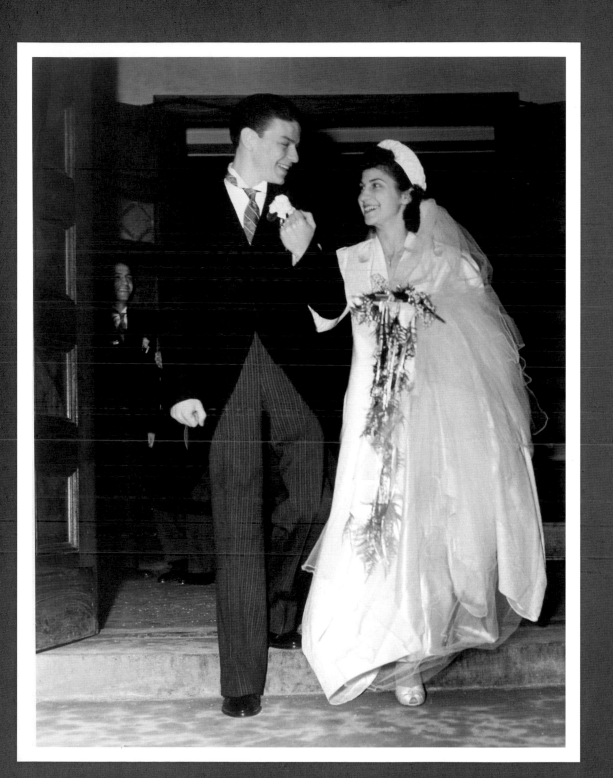

Frank and Nancy on their wedding day, February 4, 1939.

"We were married at Our Lady of Sorrows Church in Jersey City. We couldn't afford a honeymoon so we stayed in our apartment. I don't think I'd ever seen Frank so happy in his whole life." —Nancy Sinatra Sr.

"This is us in our first apartment after we were married. You can see the picture of Frank hanging on the wall behind us. Frank would type and carry on in those days."
—Nancy Sinatra Sr.

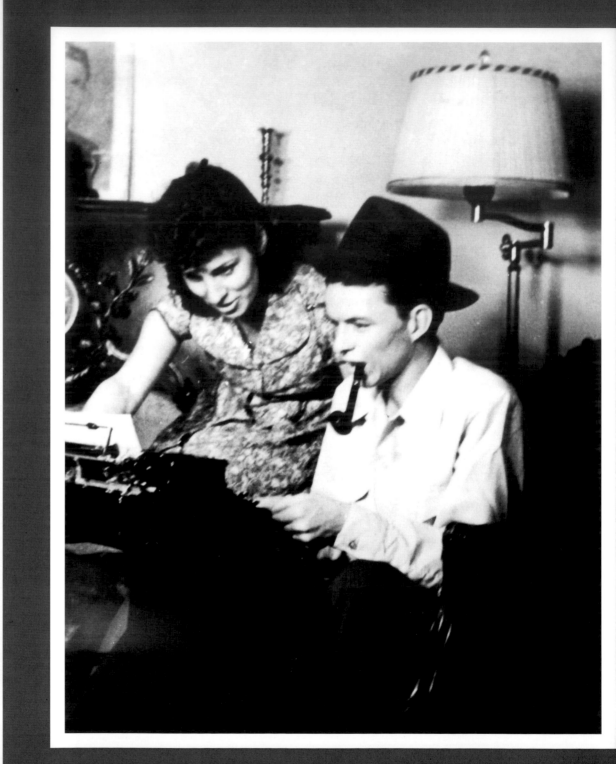

Frank and Nancy, 1939.

"This was one of the first cars we owned. I took this picture sometime around 1939. We were together twenty-four hours a day—driving from one show to another in our new car—and he was doing what he loved. It was a wonderful time." —Nancy Sinatra Sr.

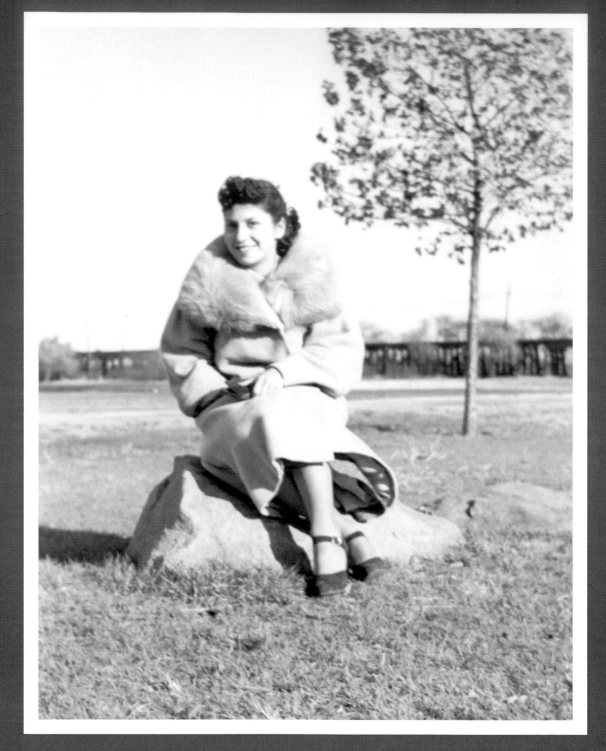

Nancy poses for Frank in the late 1930s.

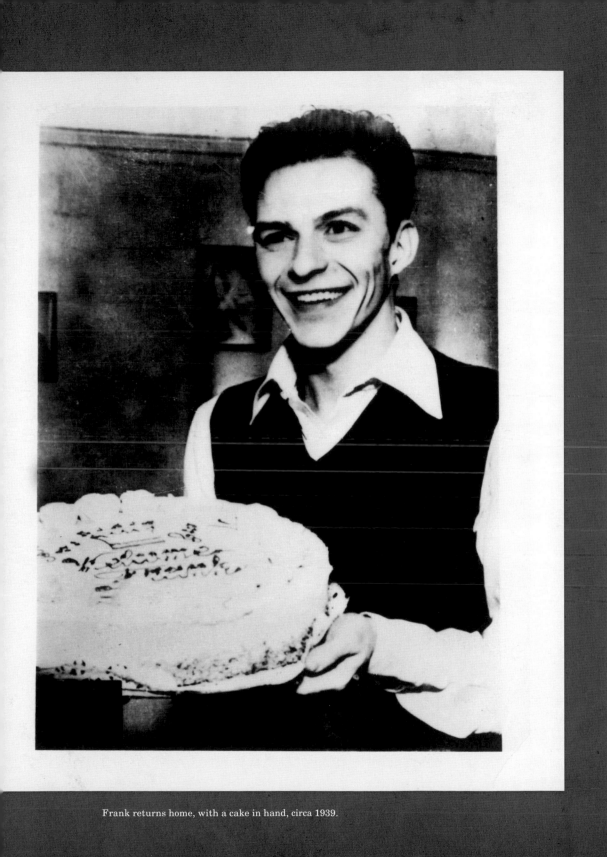

Frank returns home, with a cake in hand, circa 1939.

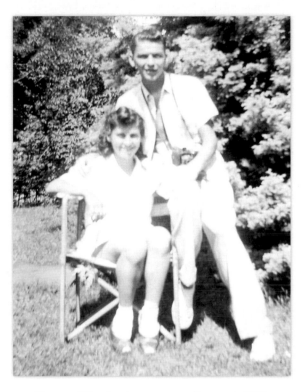

Nancy and Frank enjoy a summer afternoon in 1939.

"This was a good time in our lives. It wasn't about being rich and famous—it was about real feelings." –Nancy Sinatra Sr.

"In Nancy I found beauty, warmth and understanding; being with her was my only escape from what seemed to be a grim world."

–Frank Sinatra

Sinatra with his new employer, trumpeter Harry James, in 1939. It was Sinatra's first big break and he would remain friends with James throughout their lives.

"With Harry we traveled in a typical old fashion Greyhound bus . . . The cigarette smokers and the guys who smoked a little grass always sat in the back of the bus where the windows were open, but they didn't realize the slipstream was blowing it back into the bus again, which was absolutely hysterical. You could see a few of the guys down in front, who were partially square, take a deep breath once in a while when the smoke would come blowing by them. Those were great days for me; I learned a lot from Harry." —Frank Sinatra

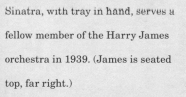

Sinatra, with tray in hand, serves a fellow member of the Harry James orchestra in 1939. (James is seated top, far right.)

"You know, if it's possible, Harry was thinner than I was. He really was a rail." —Frank Sinatra

"Harry was very nice to us when Frank was starting out; he was a very decent man." —Nancy Sinatra Sr.

Lost in the Stars

1940–1952

"I made all of his bow ties back then; this is one of mine. I had never made bow ties before so at first it was trial and error. I made ties for him in every type of pattern. Later in his life, around 1993, Frank called and asked me to make him some bow ties. I had forgotten how I did it, but luckily I still had a box with the original pattern and some fabric—I made him several solid black bow ties." —Nancy Sinatra Sr.

Wearing a bow tie Nancy made for him in the 1940s.

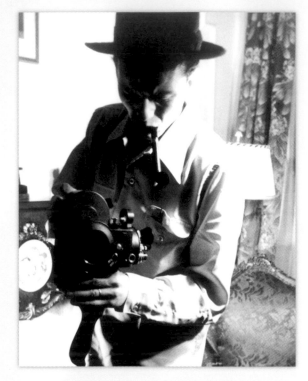

Frank, as photographed by Nancy while he
films her with his new movie camera in 1940.

"Frank was into any type of cameras in those
days; it was a hobby of his. I took this photo
(above) in the first apartment we lived in, on
Garfield Avenue, after we were married. We
received wedding gifts of a sofa and a chair
and that's how we furnished the apartment."
–Nancy Sinatra Sr.

..

(right) "At the time of this photo, I was
pregnant with Nancy, and that's why I put the
hat in front of me." –Nancy Sinatra Sr.

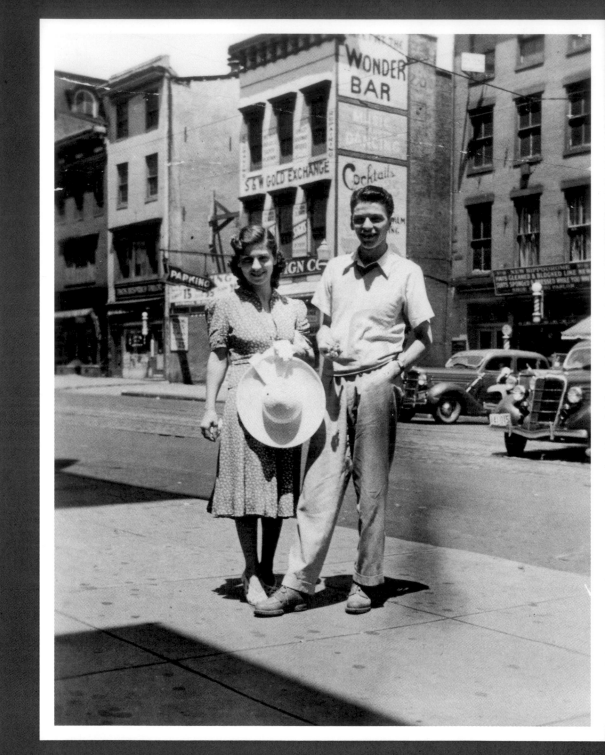

Nancy and Frank in Jersey City, 1940.

"This is Frank with Nancy, she was just about one year old, on the beach in Long Branch, New Jersey, during the summer of 1941." –Nancy Sinatra Sr.

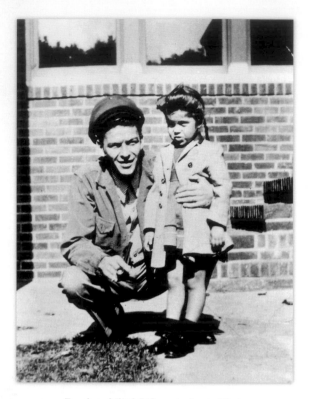

Frank and "little" Nancy in front of their
Hasbrouck Heights, New Jersey, home.

(top right) The first house Frank purchased
when he moved his family to California. The
home had at one time belonged to film actress
Mary Astor.

..

(bottom right) "We were always meeting Frank
when he came home. I was pregnant with
Frankie when this picture was taken."
—Nancy Sinatra Sr.

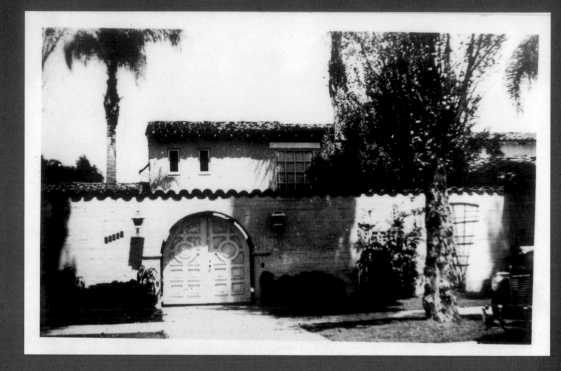

The Sinatras lived at 10051 Valley Spring Lane, Toluca Lake, from July 1944 until November 1948.

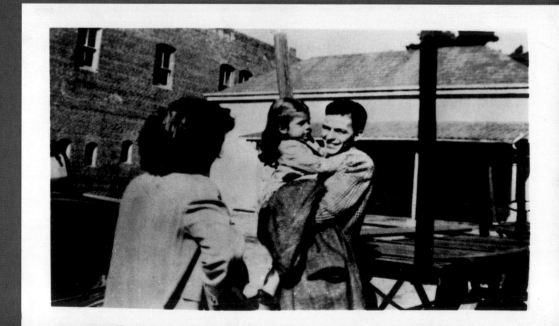

Frank greets Nancy Sr. and Jr. after returning from a trip to California in 1943.

In the early 1940s, Sinatra's fans were mostly young girls labeled "bobby-soxers." Some bobby-soxers would actually faint at the sound or sight of Sinatra—they were called "swooners."

"In the beginning I did everything, I used to sign many of his publicity pictures, and my sisters helped with the fan letters." —Nancy Sinatra Sr.

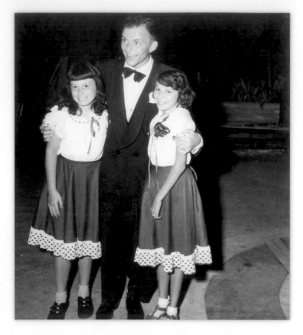

Frank poses for a photo with two young fans.

(above) "One night, when I was doing the *Hit Parade* on radio and doubling with a personal appearance at the Waldorf, I came out about 1 a.m. and two girls grabbed the loose ends of my bow tie and began a tug of war. They almost tore my head off. I had a ring around my neck for weeks." —Frank Sinatra

PS, these were not those girls.

..

(right) "There's a little bit of Manie in everything good that has ever happened to me."

—Frank Sinatra

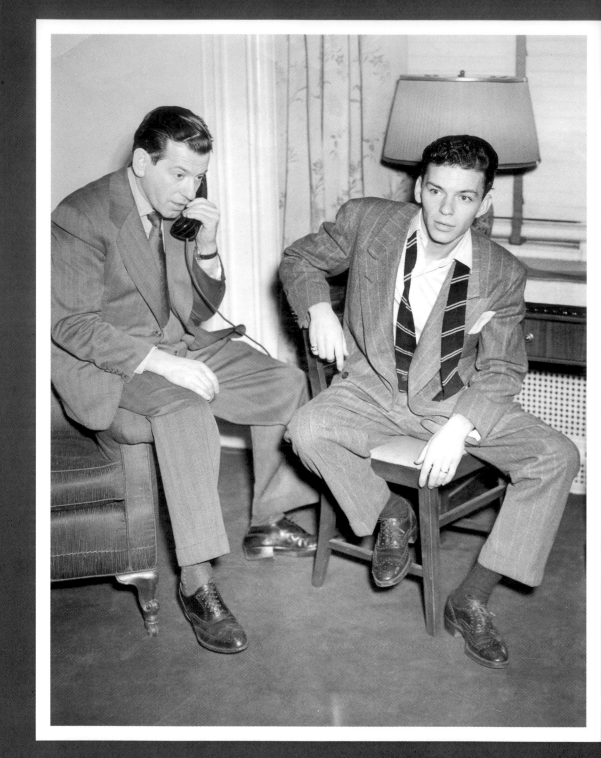

Close friend and mentor Manie Sacks with Frank after a recording session in the 1940s.

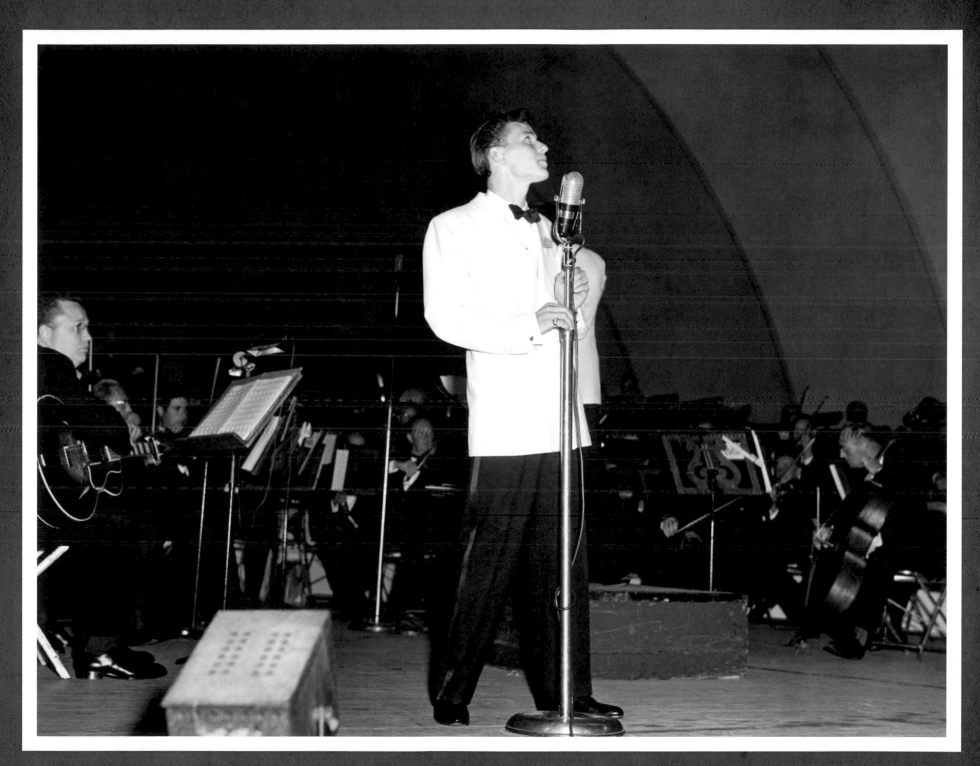

Sinatra makes his singing debut at the famed Hollywood Bowl on August 14, 1943. In 2005, Frank Sinatra was inducted into the Hollywood Bowl Hall of Fame.

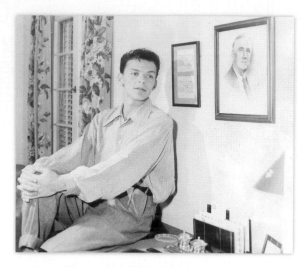

Sinatra sits on his desk next to a picture
of President Franklin Delano Roosevelt.

(above) "Frank framed the invitation he
received to go to the White House next to the
photo of President Roosevelt over his desk at
our house in Hasbrouck Heights, New Jersey.
Frank was a big admirer and supporter of
FDR—as was I." –Nancy Sinatra Sr.

..

(right) "One time in 1940, I called home at the
last minute and my pop cooked an Italian meal
for the entire Tommy Dorsey orchestra. Some
of the sax players had to eat in the hallway,
but they still loved the meal . . . He was a great
cook. My father was a darling man, a quiet
man. I adored him. In some ways, he was the
greatest man I ever knew in my life."

–Frank Sinatra

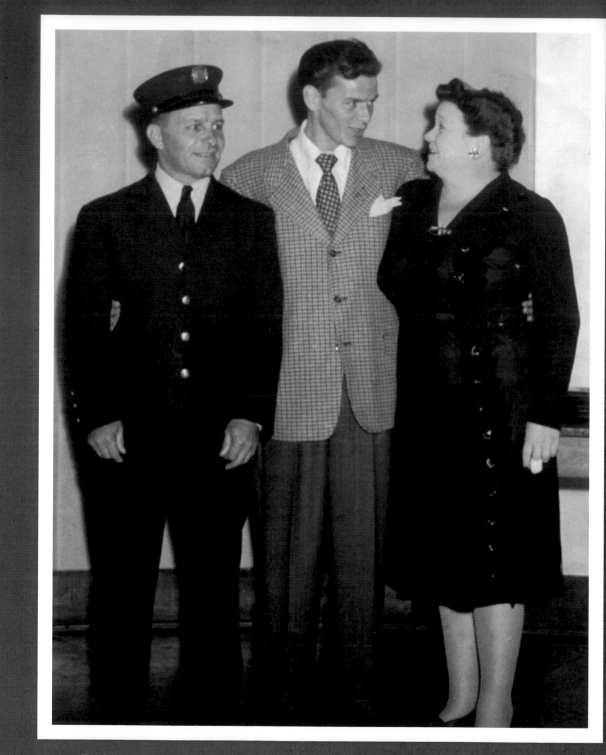

Frank with his parents, Marty and Dolly Sinatra. Marty was a captain with the Hoboken Fire Department.

Frank and Manie Sacks with Ed Wallerstein, President of Columbia Records, at the opening of the Columbia Records pressing plant in Indianapolis, circa 1945.

"My uncle Manie was Vice President in Charge of Artist and Repertoire at Columbia Records and signed Frank to the label launching Frank's career as an independent soloist. Frank and Manie remained close friends through the years." —Herman Rush

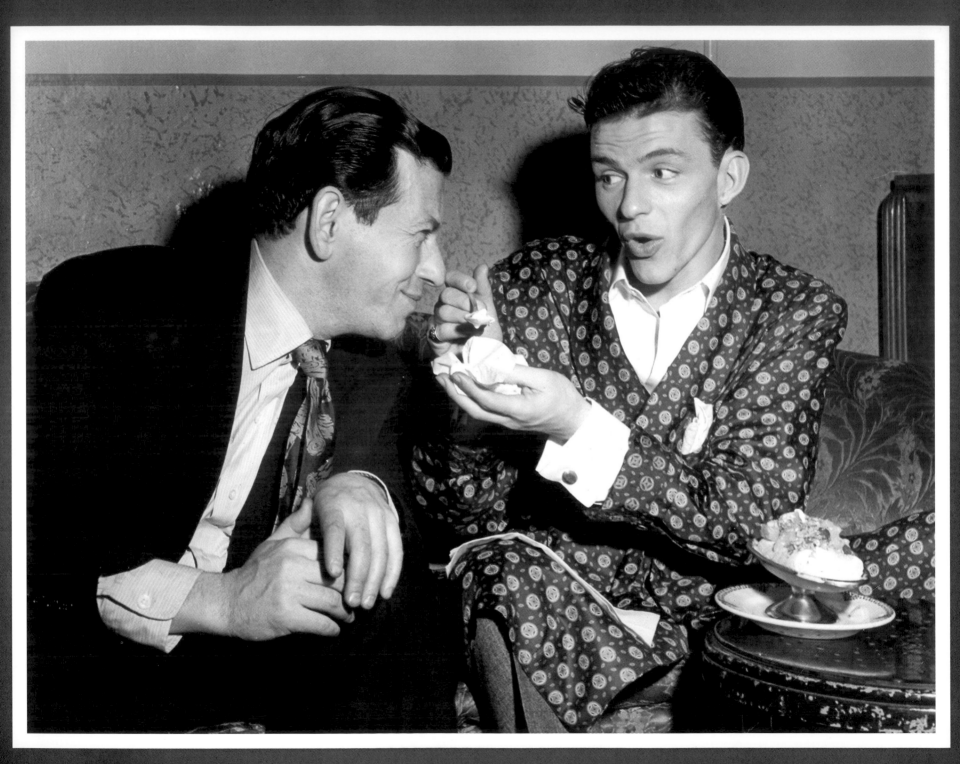

Sharing ice cream with Manie Sacks, backstage at the Paramount Theatre in New York.

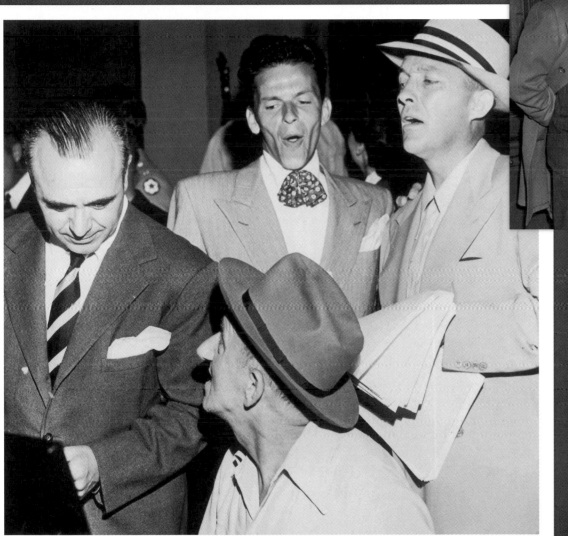

Jimmy Durante (at the piano), José Iturbi, Sinatra, and Bing Crosby rehearse for a radio appearance in 1945.

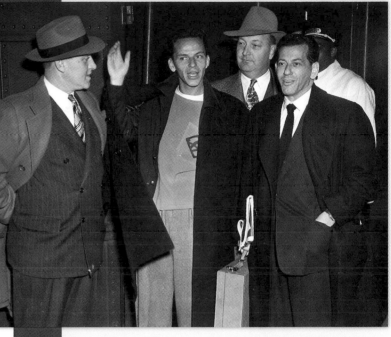

Sinatra arriving in Philadelphia on November 11, 1946, with Manie Sacks (far right).

Sinatra would usually do six shows a day at the Paramount, beginning at 11 a.m.

..

"Jimmy Durante, what can I say . . . he was a bar of sweet chocolate . . . he was a dear, sweet, man . . . what a darling man."

—Frank Sinatra

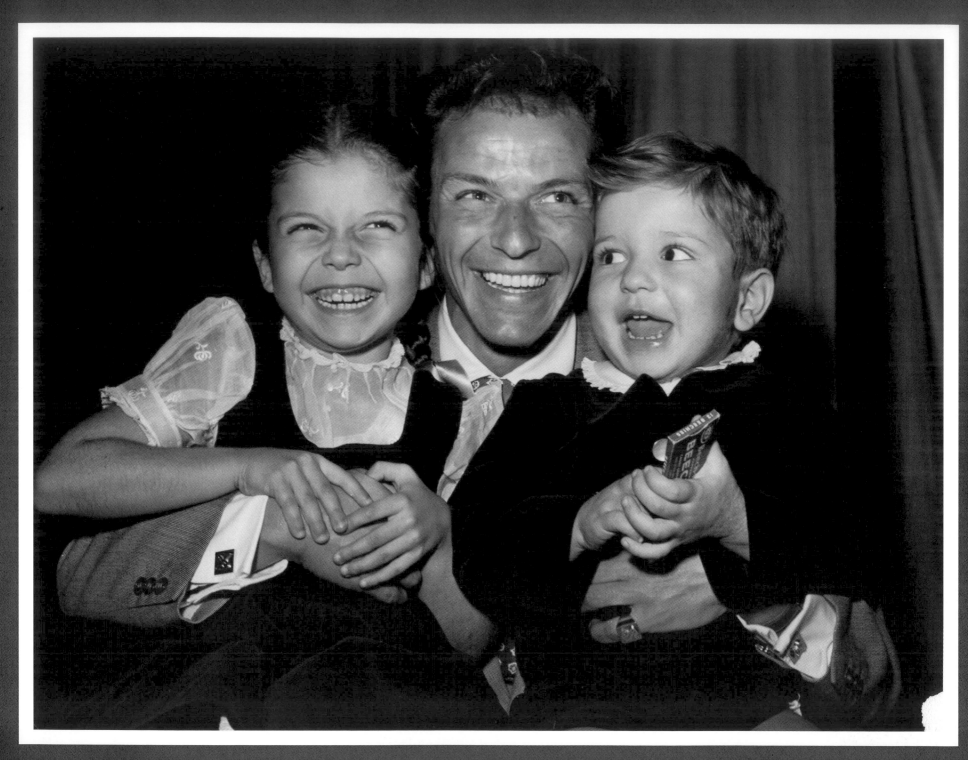

Nancy and Frankie pose for this photo with their father in 1946.

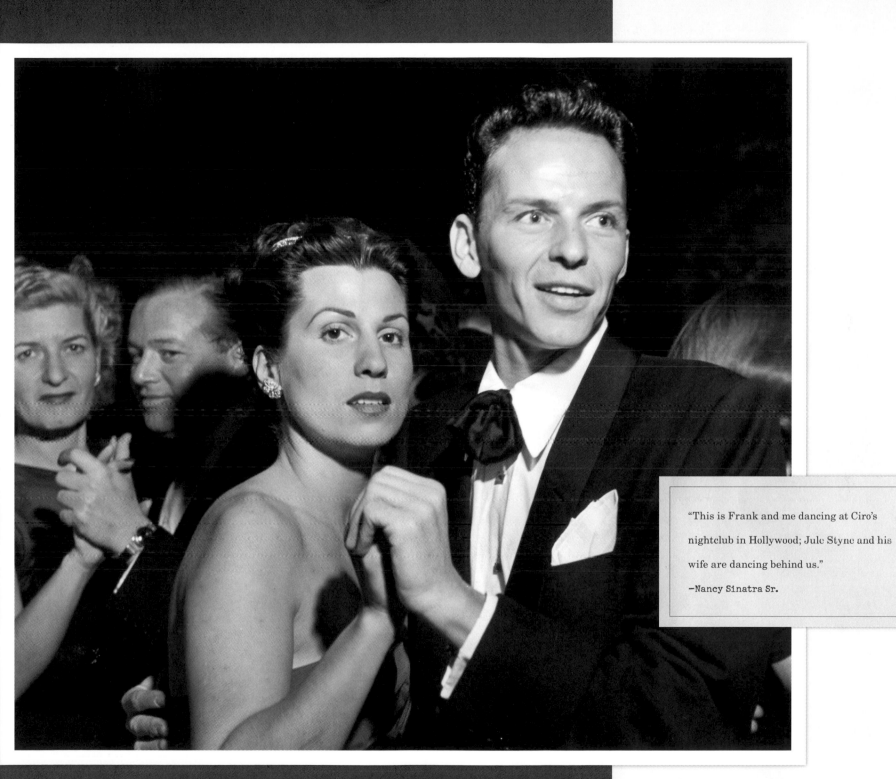

"This is Frank and me dancing at Ciro's nightclub in Hollywood; Jule Styne and his wife are dancing behind us."

—Nancy Sinatra Sr.

Nancy and Frank—a lovely way to spend an evening, 1946.

Sinatra and friends, including Robert Alda and Jack Carson, board a Western Airlines flight in Los Angeles to Texas. Al Viola is standing above the priest, on the right side of the stairs.

"I did a benefit with Frank, as part of the Page Cavanaugh Trio, in the spring of 1947. Frank called our manager, Bullets Durgom, to have the trio perform with him in Galveston, Texas. It was a benefit for the victims of the Texas City petroleum explosion. This man gave to others all his life; he cared about other human beings, not just himself." —Al Viola (Sinatra's guitarist)

During his engagement at the Wedgewood Room of the Waldorf-Astoria, Frank gets a birthday cake from the Page Cavanaugh Trio: Page on piano, Al Viola on guitar, and Lloyd Pratt on bass.

"Frank only did the supper show starting at 10:30 p.m., and the cover charge was $2.00. The bandleader was Emil Coleman, and Frank had Axel Stordahl write special arrangements for the trio to augment the orchestra." —Al Viola

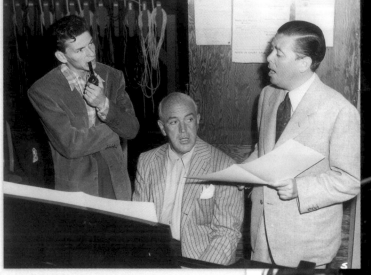

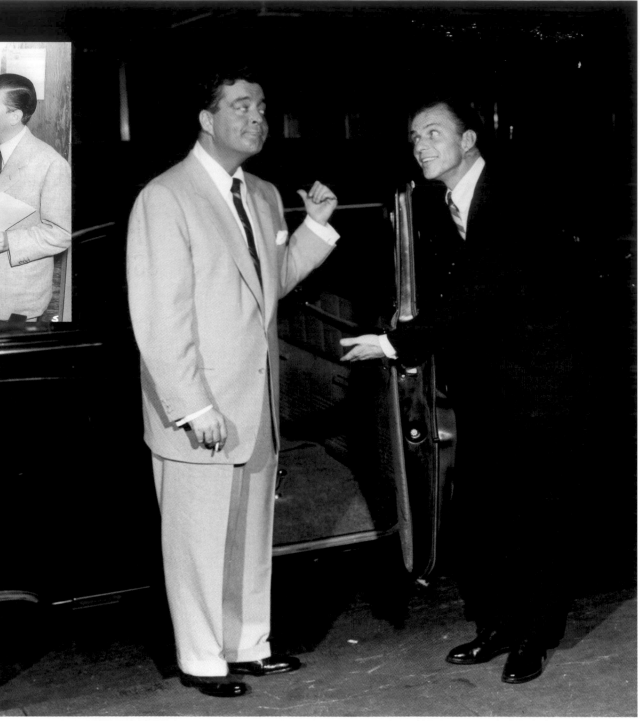

(above) Sinatra on the set of *Higher and Higher* at RKO with songwriters Jimmy McHugh and Harold Adamson in 1943. The movie also starred Jack Haley, Victor Borge, and Mel Tormé.

···

(right) Jackie Gleason, aka "The Great One," and Sinatra outside of Toots Shor's saloon in New York. Gleason would appear as a guest on Sinatra's CBS television show in the early 1950s.

Sinatra signs an autograph while attending a play with wife, Nancy. Axel Stordahl,
Sinatra's arranger and musical director, is sitting on the other side of Nancy.

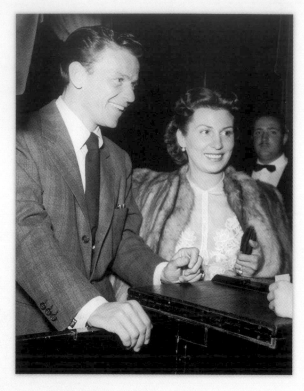

Frank and Nancy enjoy an evening out in 1947.

"I remember visiting my father on the set of
The Kissing Bandit. He wore the most beautiful
costume, beaded and embroidered. I thought he
was the handsomest man in the whole world."
—Nancy Sinatra Jr.

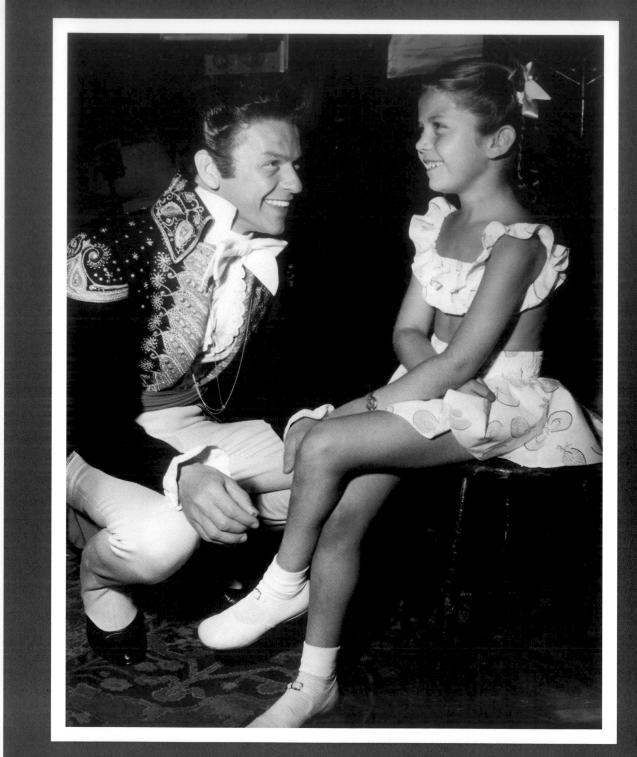

With Nancy Jr. at MGM Studios in 1948.

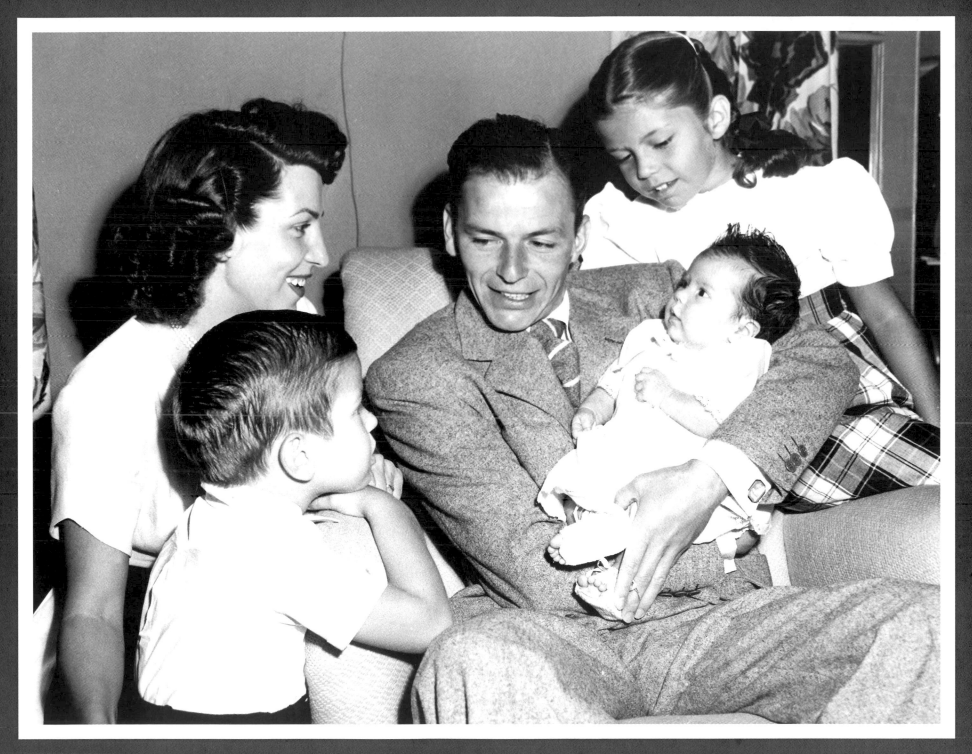

The Sinatra family welcomes baby Tina, born on June 20, 1948—a perfect Father's Day gift for Frank.

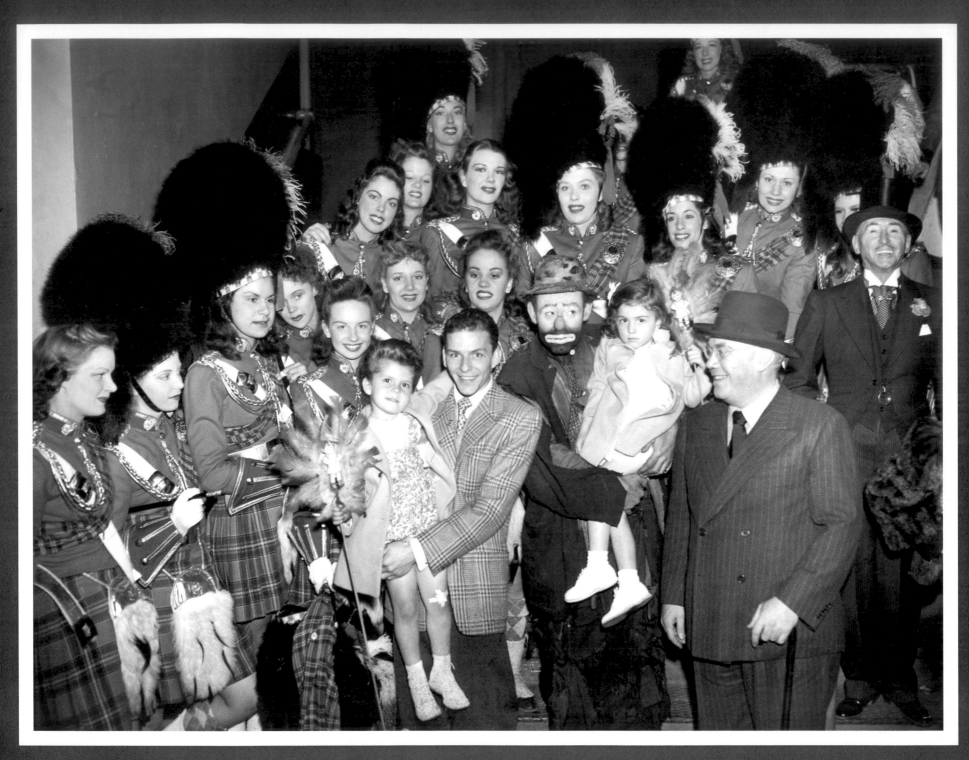

Frank and daughter Nancy Jr. spend a day at the circus. Famous clown Emmett Kelly stands next to Sinatra.

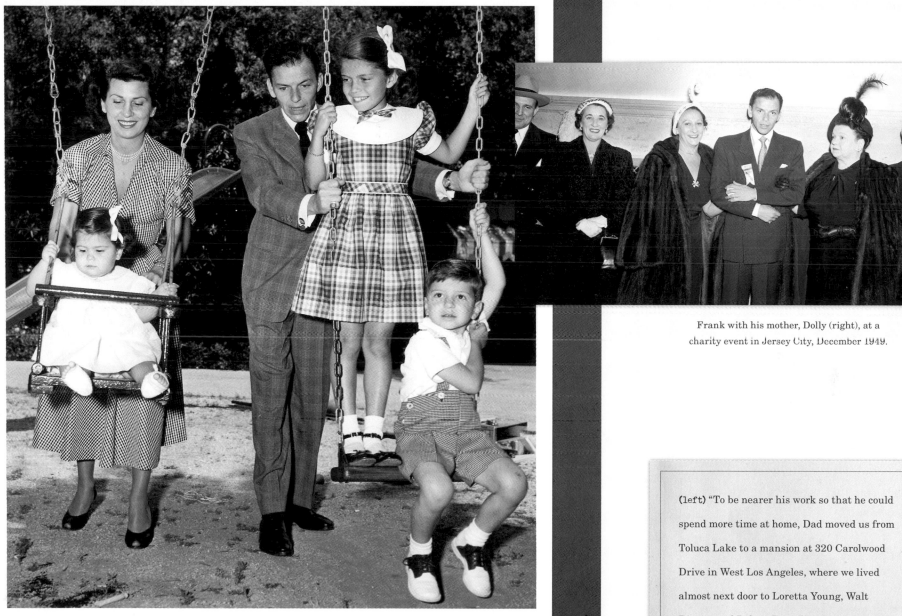

Frank with his mother, Dolly (right), at a
charity event in Jersey City, December 1949.

Nancy and Frank playing with the kids in their yard, 1949.

(left) "To be nearer his work so that he could
spend more time at home, Dad moved us from
Toluca Lake to a mansion at 320 Carolwood
Drive in West Los Angeles, where we lived
almost next door to Loretta Young, Walt
Disney, and Robert Ryan."

—Nancy Sinatra Jr.

Sinatra listening to a record by alto saxophonist Alvy West and "the little band," 1949. "Frank liked all kinds of music. My father introduced Frank to opera, which led into the classics; he loved listening to classical music." —Nancy Sinatra Sr.

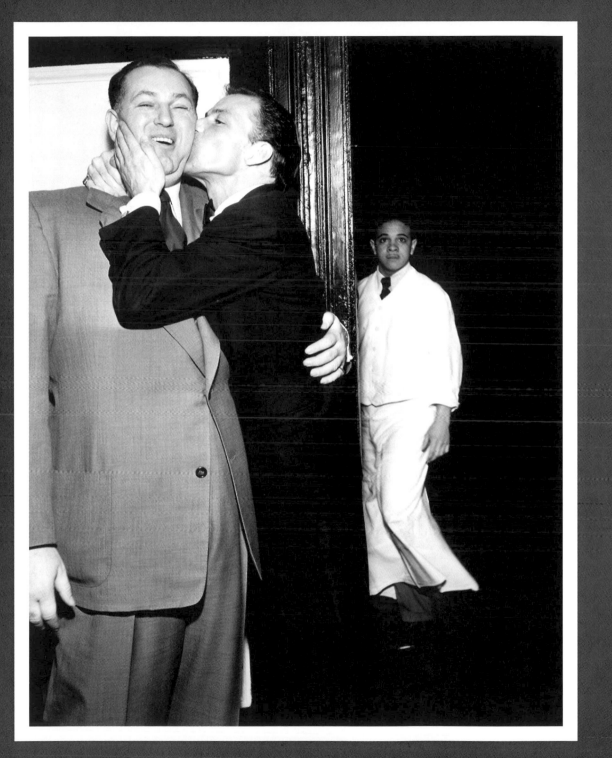

Sinatra kisses Jack Entratter on the cheek during his engagement in April 1950 at the Copacabana in New York.

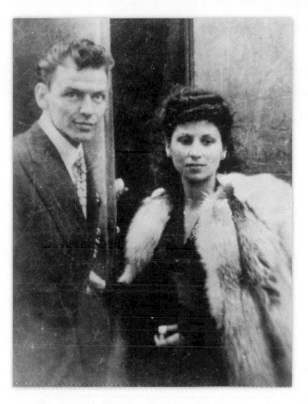

Frank and Nancy backstage before a concert performance.

(left) Jack Entratter, then the general manager of the Copa, would head to Las Vegas a few years later to become the entertainment director of the Sands Hotel.

Very Good Years

1953–1970

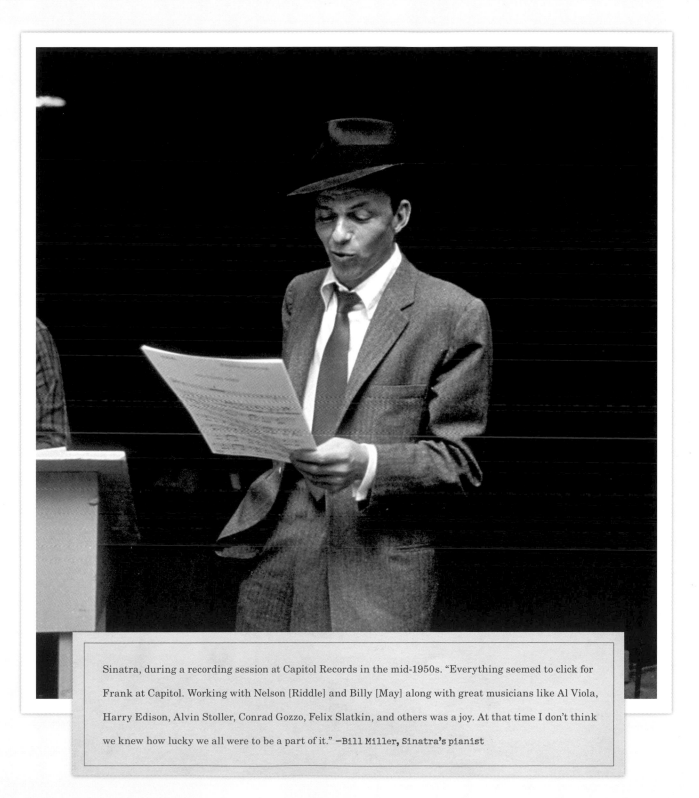

Sinatra, during a recording session at Capitol Records in the mid-1950s. "Everything seemed to click for Frank at Capitol. Working with Nelson [Riddle] and Billy [May] along with great musicians like Al Viola, Harry Edison, Alvin Stoller, Conrad Gozzo, Felix Slatkin, and others was a joy. At that time I don't think we knew how lucky we all were to be a part of it." —Bill Miller, Sinatra's pianist

Montgomery Clift and director Fred Zinnemann on the set of *From Here to Eternity* with Sinatra in 1953. "At thirty-eight years old, I was a has-been. My only collateral was a dream," said Sinatra, who won an Academy Award for Best Supporting Actor, as Maggio.

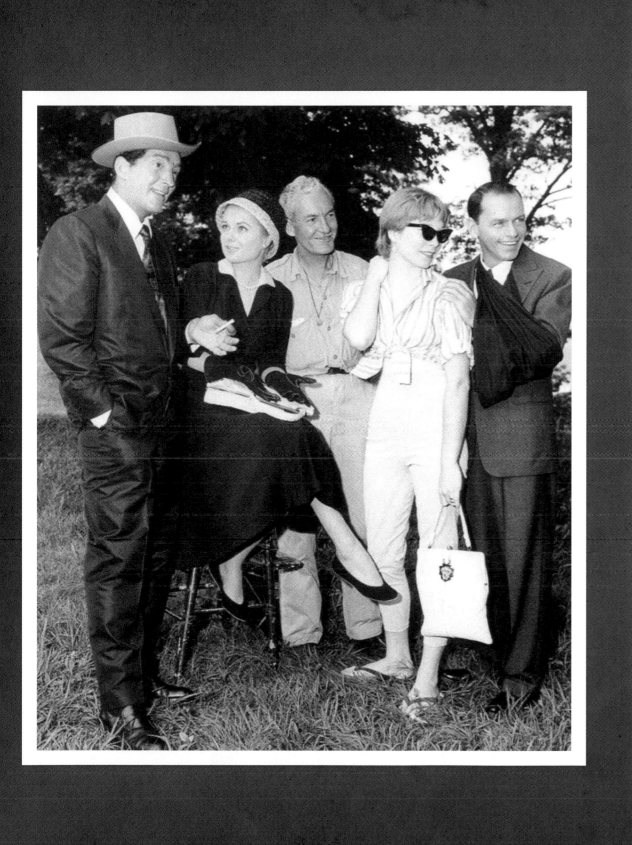

(left) Dean Martin, Martha Hyer, assistant director William McGarry, Shirley MacLaine, and Frank on the set of *Some Came Running* in Madison, Indiana, 1958.

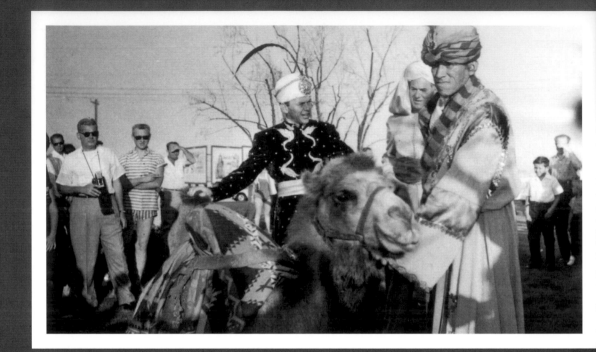

Sinatra, in a sultan costume, makes a special appearance at the opening of the Dunes Hotel in Las Vegas, 1955.

(bottom) Sinatra behind the wheel of his 1955 Ford Thunderbird convertible. The car, which was delivered to Sinatra in late 1954, included a removable fiberglass top as a standard feature.

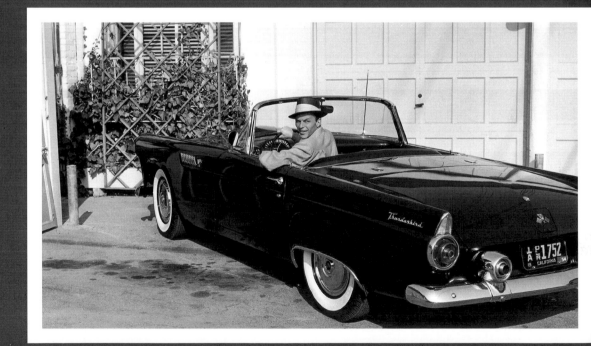

Sinatra behind the wheel of his 1955 Ford Thunderbird convertible.

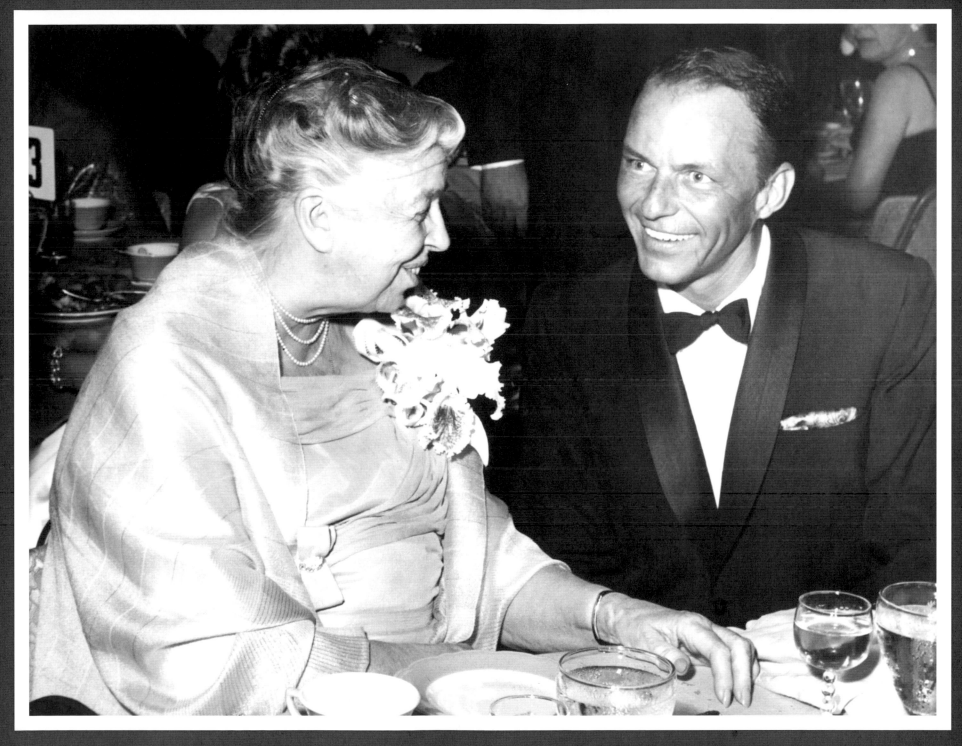

Frank with Eleanor Roosevelt at a reception in her honor, in Chicago, August 1956.

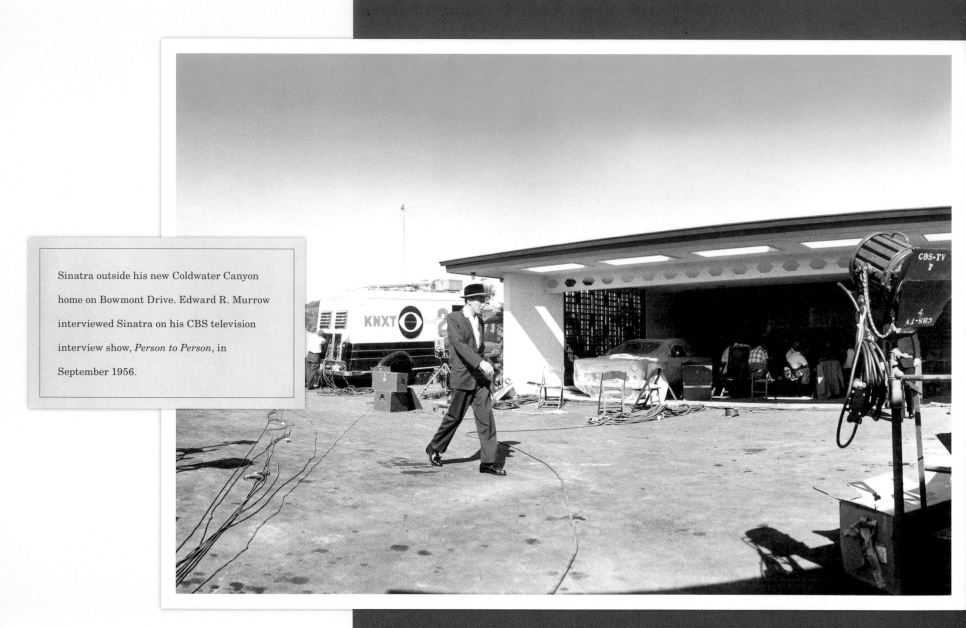

Sinatra outside his new Coldwater Canyon home on Bowmont Drive. Edward R. Murrow interviewed Sinatra on his CBS television interview show, *Person to Person*, in September 1956.

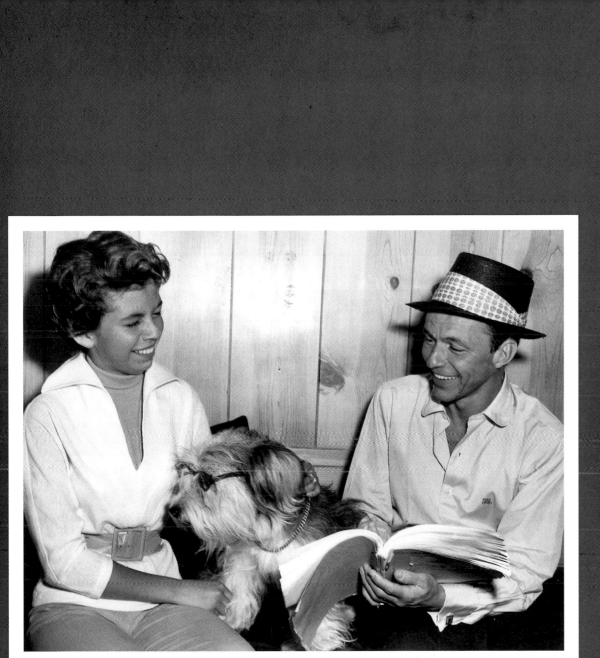

(above) Director Charles Vidor and producer Samuel J. Briskin discuss a scene with Frank on the set of *The Joker Is Wild* in 1957. The film was based on the life of nightclub entertainer Joe E. Lewis.

"Joe was humorous, he was sweet, he was gentle, and he was never blue with his material. I loved that particular film because I loved him as a human being." —Frank Sinatra

(left) Nancy visits her father on the set of *The Tender Trap* at MGM. Butch, a Skye terrier, reviews the script in between scenes for the 1955 film that also starred Debbie Reynolds.

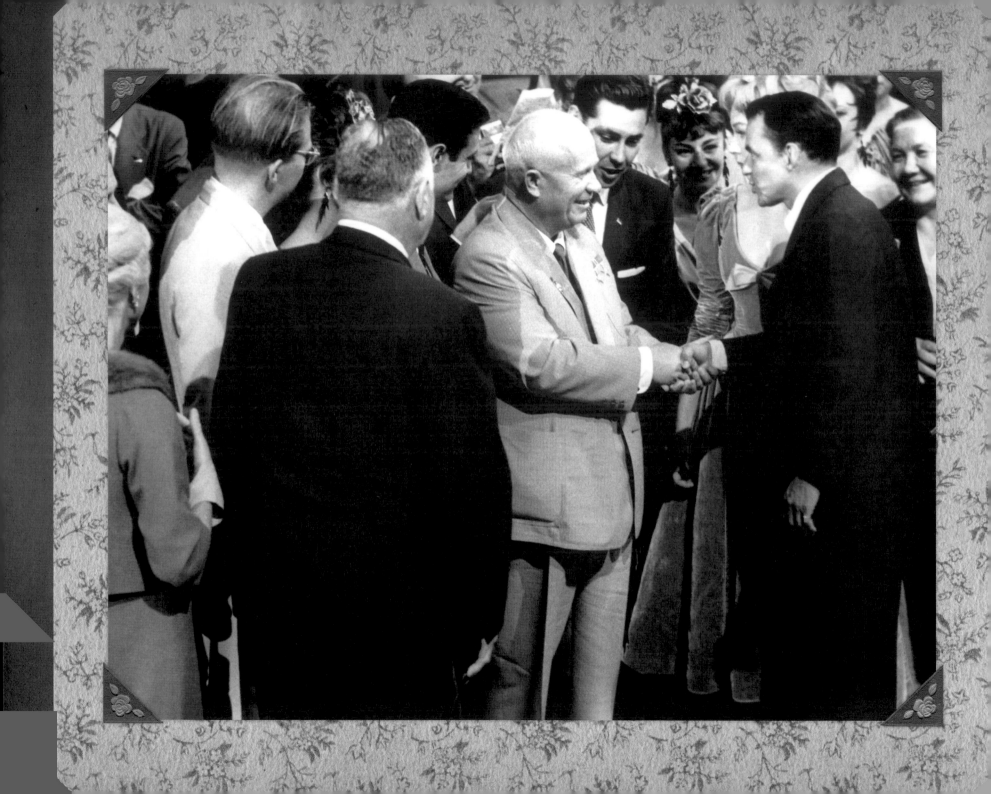

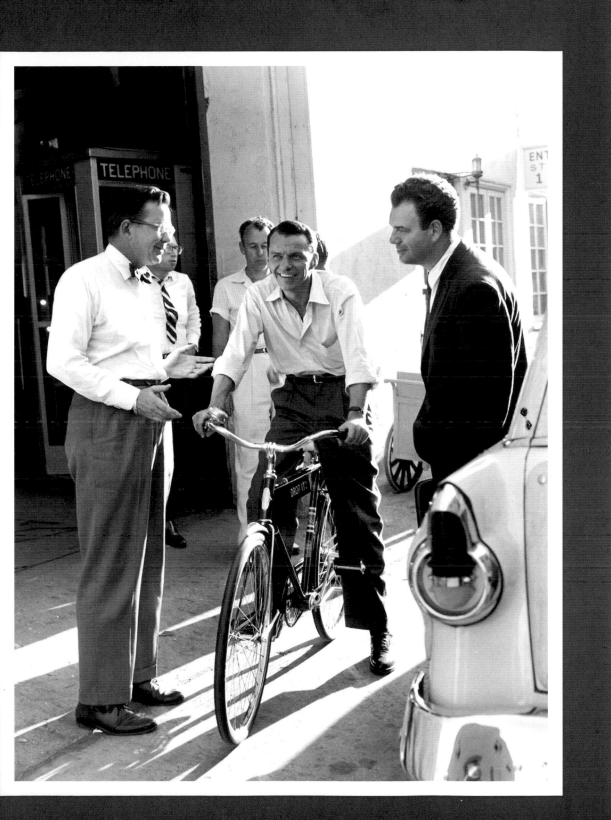

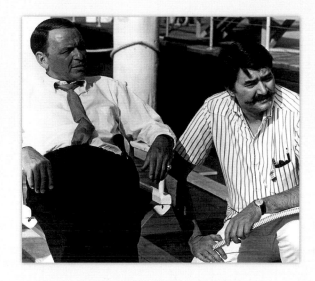

(far left) Soviet Premier Nikita Khrushchev meets Sinatra while visiting the set of *Can-Can* in 1959. Mrs. Khrushchev beams while standing behind Sinatra, who hosted a luncheon for the visiting dignitaries at Twentieth Century Fox.

(left) Sinatra, using a bicycle for transportation on the studio back lot, stops to talk with arranger Nelson Riddle in the 1950s.

(above) Frank with artist LeRoy Neiman on location in Miami, Florida, filming *Tony Rome*, in 1967. Over the years, Neiman would do many paintings of Sinatra, including the covers for his *Duets* CDs in the 1990s.

Bing Crosby and Frank review their lines while filming
Happy Holidays with Bing and Frank in December 1957.

(above) Sinatra directed this episode, which
aired on ABC as part of his series, *The Frank
Sinatra Show*.

..

(right) This filmed episode never aired during
the series run on ABC.

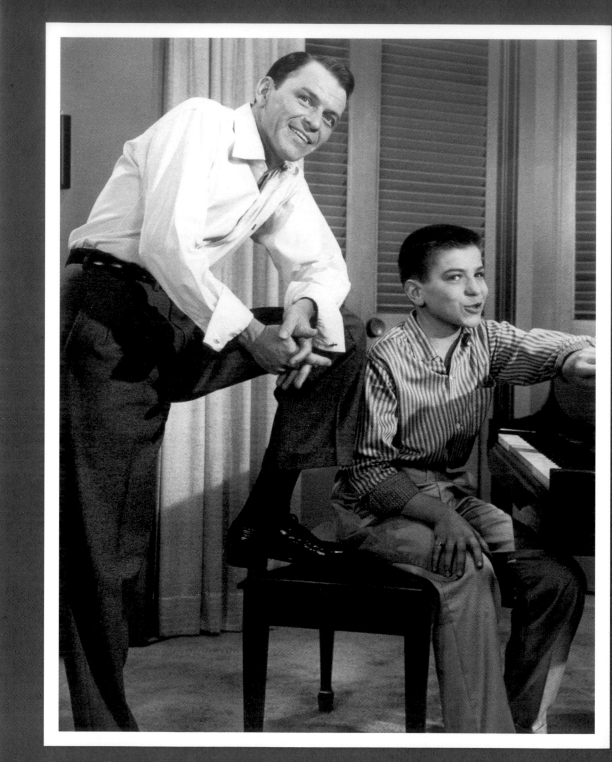

Sinatras, father and son, rehearse "My Blue Heaven" on the set of *The Frank Sinatra Show* in 1958.

Sinatra sings along with jazz pianist and composer Erroll Garner as actress Angie Dickinson looks on at a private party in the late 1950s.

Jack Entratter and Jimmy Van Heusen stand by as Sinatra records a song. "I adore making records. I'd rather do that than almost anything else. You can never do anything in life quite on your own—you don't live on your own little island. Making a record is as near as you can get to it—although, of course, the arranger and the orchestra play an enormous part. But once you're on that record singing, it's you and you alone." –Frank Sinatra

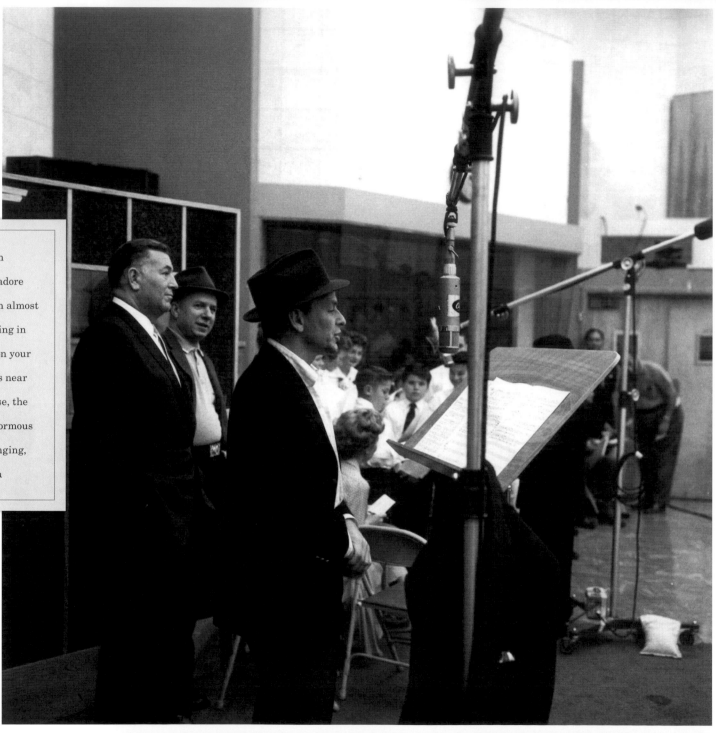

"It was fun recording with Frank; it was always fun. A lot of people said that he was hard to work with, but I never had any trouble with him. Frank rarely asked me to change an arrangement. He was so knowledgeable musically—especially about the type of stuff I wrote for him—that if he did have an idea or suggestion it usually made sense musically. Most of the time Frank was specific in what he wanted, but sometimes he'd say, 'I don't know what the hell to do with this tune, just do what you want.'" —Billy May (pictured above, in studio with Sinatra)

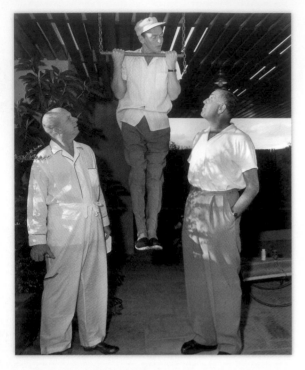

Jimmy Van Heusen and Jack Entratter observe Sinatra
doing pull-ups in the carport of the Presidential Suite
at the Sands Hotel, Las Vegas, April 1958.

During this period in his career, Sinatra
worked almost nonstop. In April 1958, for
example, he played a two-week engagement at
the Sands, Las Vegas, and also filmed a few
episodes of his ABC-TV series.

Sinatra on the set of his ABC series *The Frank Sinatra Show* in April 1958, rehearsing a song.

Frank and co-star Eddie Hodges have a quick rehearsal of the song "High Hopes" before filming the scene for the movie *A Hole in the Head*, November 1958. The film, directed by Frank Capra, was shot on location in Miami, Florida. Songwriters Jimmy Van Heusen, at the piano, and Sammy Cahn lend their support.

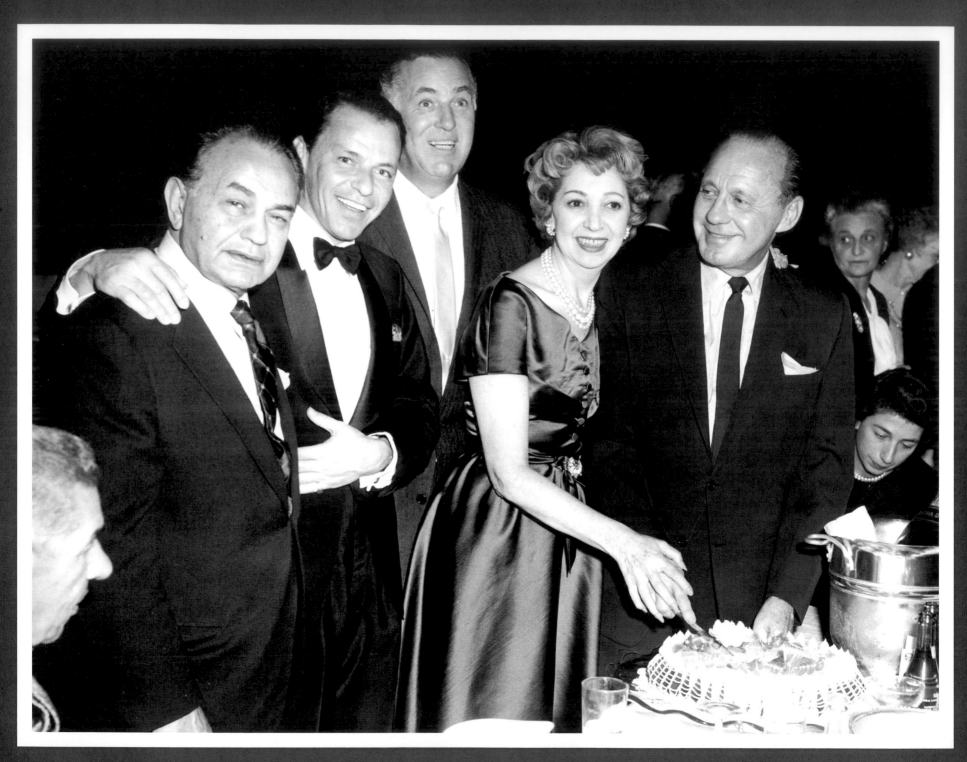

Celebrating Mary and Jack Benny's wedding anniversary at the Sands Hotel, Las Vegas, January 1958.

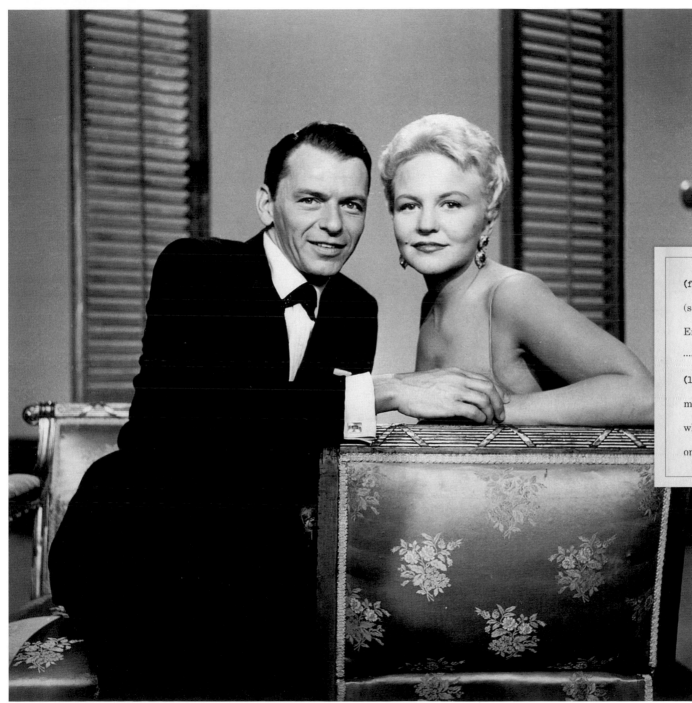

Frank and Peggy Lee on the set of *The Frank Sinatra Show.*

(far left) Pictured are Mike Romanoff (seated), Edward G. Robinson, Frank, Jack Entratter, and Mary and Jack Benny.

..

(left) Peggy Lee would be the only guest to make three appearances on Sinatra's show, which aired for one season on ABC in 1957–58; one show with Lee was filmed but never aired.

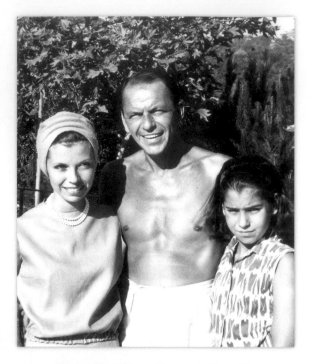

Frank with daughters Nancy and Tina at his home on Bowmont Drive in Beverly Hills, 1959.

No other singer of his era traveled more than Frank Sinatra; he was an international superstar. When he wasn't on the road, he enjoyed relaxing by his pool—usually doing a crossword puzzle.

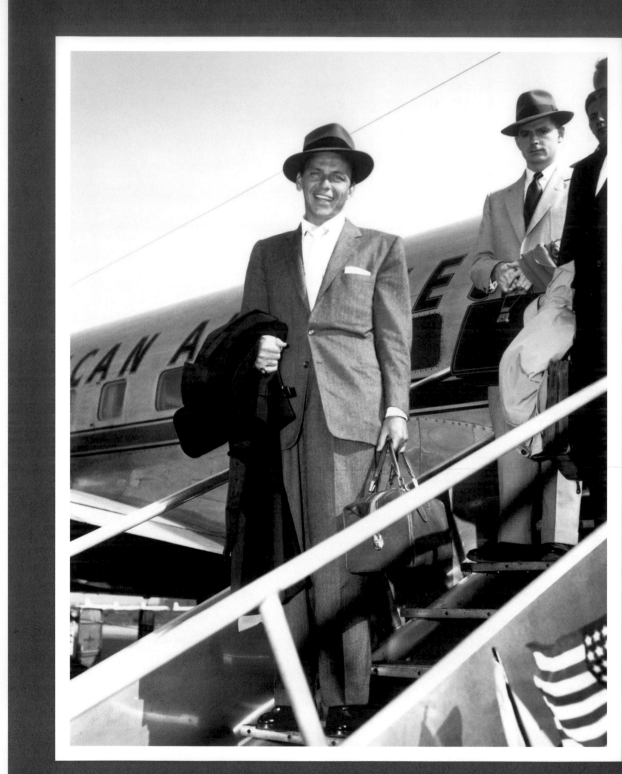

Come fly with me.

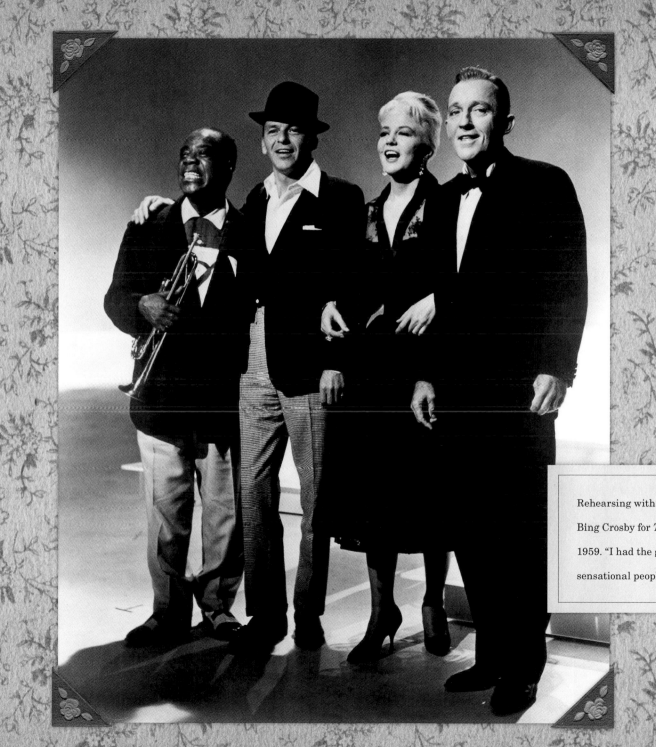

Rehearsing with Louis Armstrong, Peggy Lee, and Bing Crosby for *The Bing Crosby Show* in September 1959. "I had the good fortune of working with some sensational people . . . some luck!" —Frank Sinatra

"Throughout the years on the record dates I've done, I've never been comfortable in a separate room away from the orchestra. I cannot work that way when recording because I feel I need the support of the sound of the orchestra in the room. I know I've driven engineers crazy because they try to isolate me from the velocity of the band." —Frank Sinatra

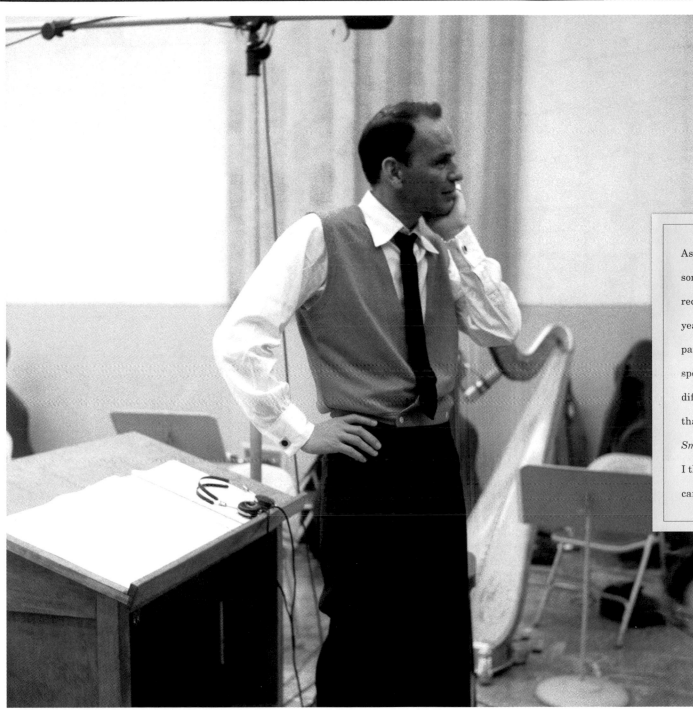

1953

Asked once late in his career to name a favorite song or album, Sinatra said, "I've sung and recorded so many wonderful songs over the years it would be impossible to name one in particular as my favorite. Many of them are special to me for one reason or another. It's difficult to pick a favorite album. The ones that stick in my mind are *Only the Lonely*, *Wee Small Hours*, and *Come Fly With Me* because I think the orchestrator's work and my work came together so well."

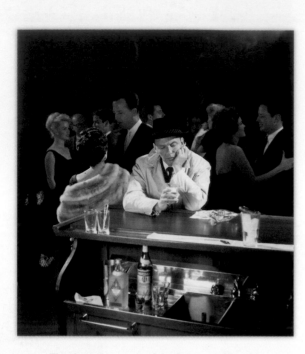

The photo that was used for the cover of Frank's classic ballad album *No One Cares*.

(above) "Whenever Frank sings a song, no matter how good or bad the song is, he believes in it totally. He knows how to sing a song better than anyone else in the world."

— *No One Cares* arranger Gordon Jenkins

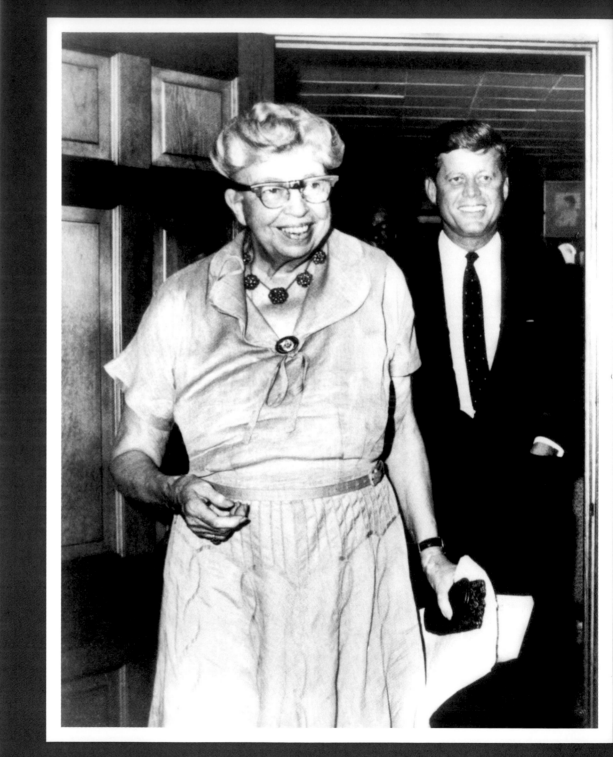

Frank took this photo of Eleanor Roosevelt and John Kennedy during JFK's presidential campaign.

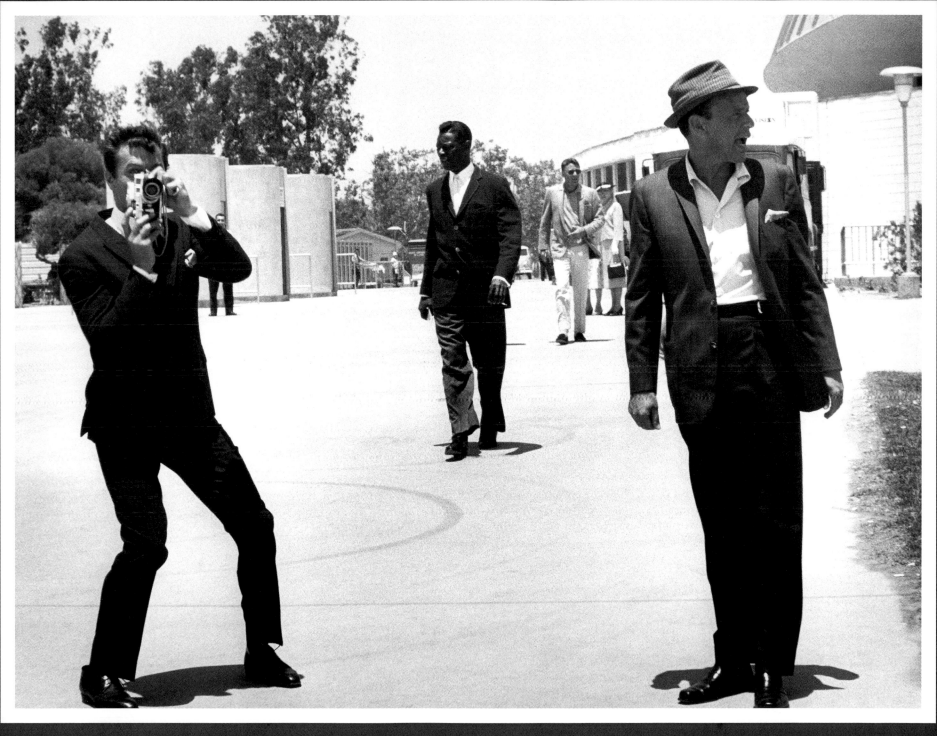

Tony Curtis (with camera), Nat King Cole, Peter Lawford, and Frank Sinatra in Washington, D.C., on their way to rehearse for JFK's Inaugural Gala, organized by Frank, January 1961.

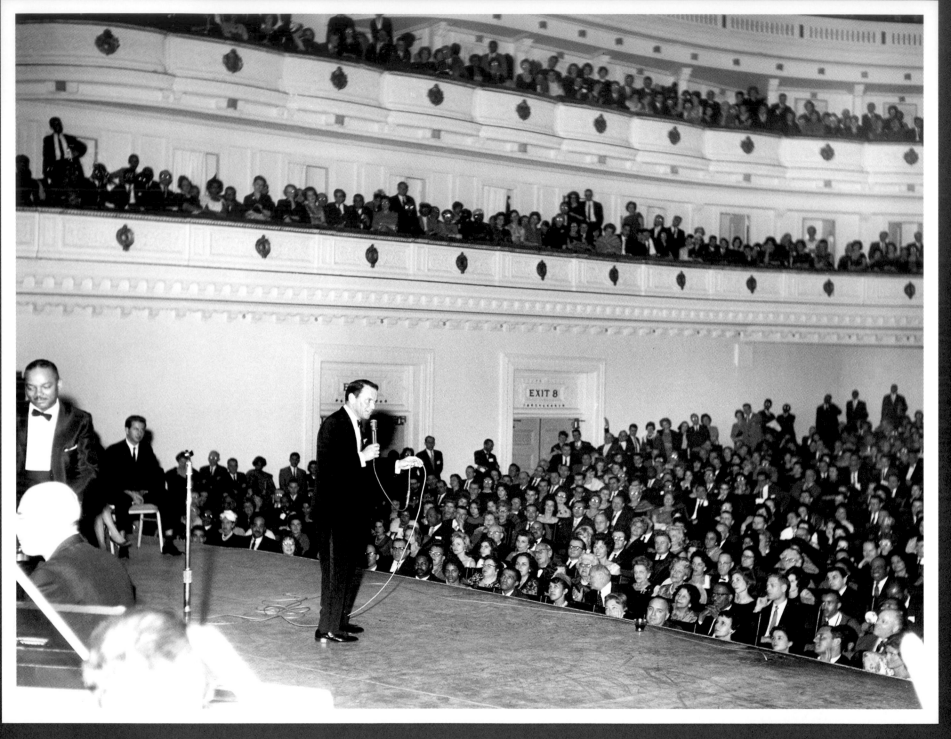

Frank Sinatra at Carnegie Hall during a benefit for Dr. Martin Luther King Jr.'s Southern Christian Leadership Conference, January 27, 1961.

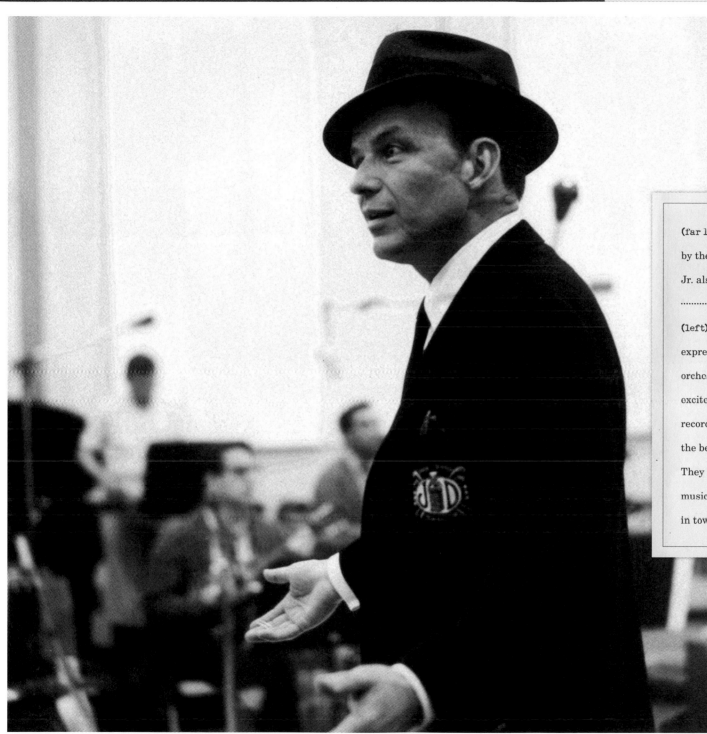

(far left) Sy Oliver conducts and Ken Lane sits by the piano; Dean Martin and Sammy Davis Jr. also performed that evening.

...

(left) Sinatra in the recording studio expressing the feeling he wants from the orchestra. "There was a tremendous level of excitement—air of expectation—every time he recorded. Everyone knew they were making the best records around. How could they miss? They had the best singer, best arrangers, best musicians, best engineers, and the best studios in town." —Frank Sinatra Jr.

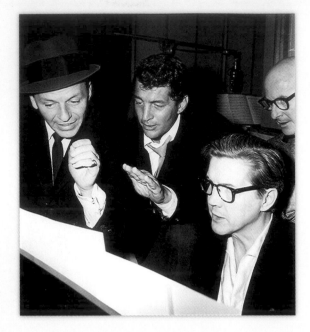

(above) Sinatra and Dean Martin rehearse a
song for their upcoming television appearance
on the Judy Garland Show. At the piano is
Sinatra's pianist Bill Miller, with Ken Lane,
Dean's pianist, looking over his shoulder.
February 1962.

"I had the greatest job in the world as
a pianist. I accompanied the best singer in
the business and was able to travel the world
making music with him . . . not a bad gig!"
—Bill Miller

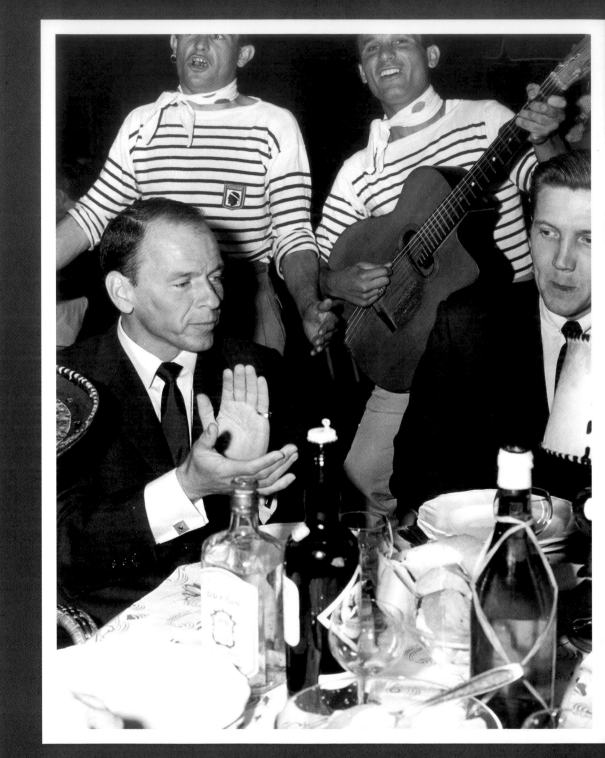

Frank and Bill Miller having dinner after a benefit concert in Mexico City, April 1961.

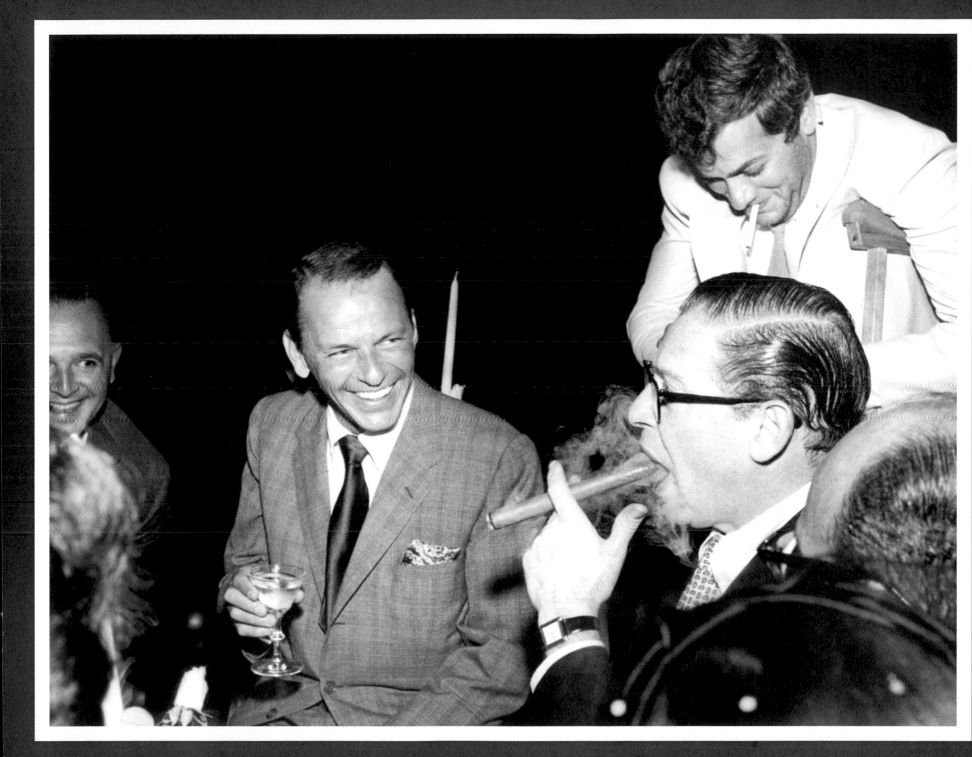

Sinatra with Milton Berle and Tony Curtis, enjoying themselves at a Hollywood function.

Sands

A PLACE
IN THE SUN

FRANK SINATRA
MARTY ALLEN & STEVE ROSSI
THE MOST BEAUTIFUL GIRLS IN THE WEST
ANTONIO MORELLI AND HIS MUSIC

The marquee for Frank's appearance at the Sands, Las Vegas in November 1961. Sinatra would appear at the Sands from 1953 to 1967, making history with his legendary engagements that helped turn the desert city into a worldwide tourist destination.

"Frank and Las Vegas were a perfect combination; it was magic. He always seemed to have a wonderful time there. Frank made Las Vegas what it is." –Angie Dickinson

Frank with arranger-composer-conductor
Neal Hefti at a recording session in 1962.

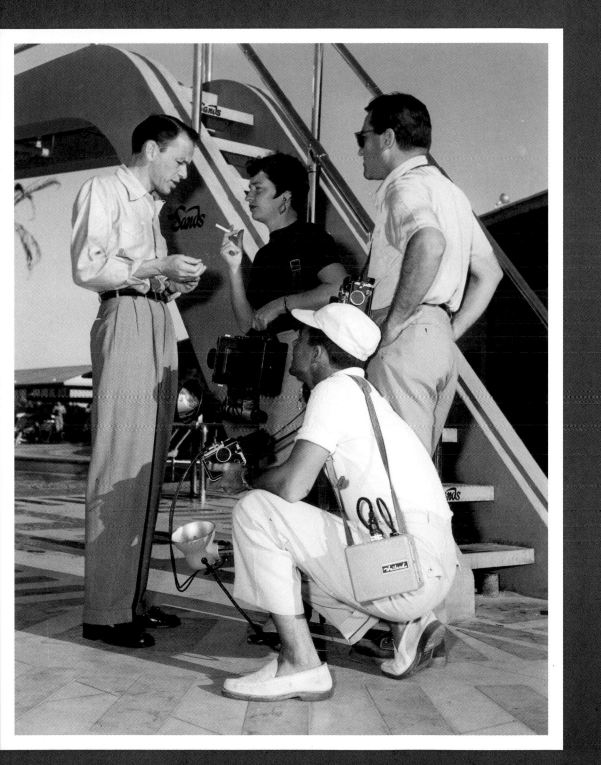

Frank being interviewed poolside at the Sands Hotel.

(left) "Frank really looked forward to going to
work in Vegas, and so did I. We hung out pretty
good in those days. I don't think we ever went
to bed until four or five in the morning."
—Bill Miller

...

(above) Hefti wrote several classic arrange-
ments for Sinatra, including those for his first
recordings with Count Basie, *Sinatra-Basie:
An Historic Musical First*.

"In 1962, we went on a world tour for about ten weeks. Frank worked very hard on that trip because all proceeds went to children's charities in each country. He went to hospitals to see the children; he was getting up in the morning so he could go. Frank always looked out for the less fortunate. I can't begin to tell you how many benefits Frank did over the years and paid the costs of the band out of his own pocket. I think some years Frank did more benefits than paying gigs. He was a very generous human being." –Al Viola

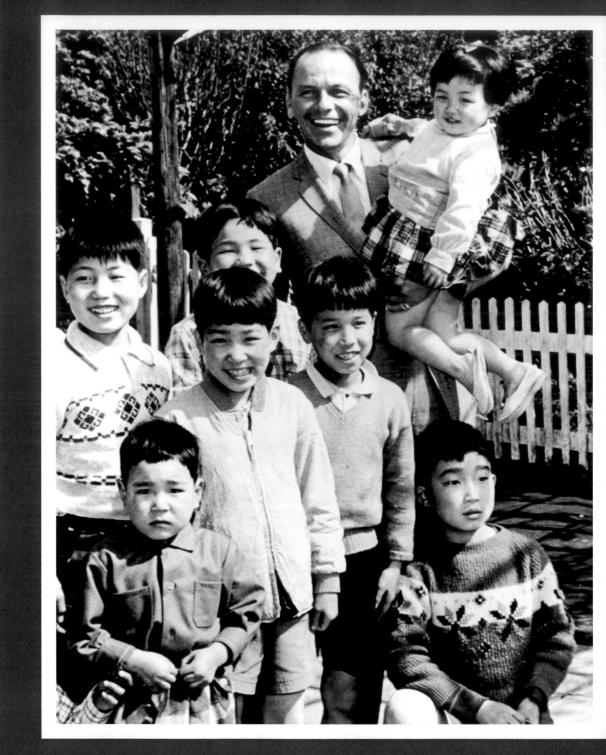

Frank with some new fans during his 1962 world tour benefiting children's charities.

"I'm not old enough to understand adults, but I think I know enough to understand kids. And I think if we can get the kids together, maybe we'll be able to keep them together when they get to be adults." —Frank Sinatra

Frank took this photo of the Coliseum in Rome.

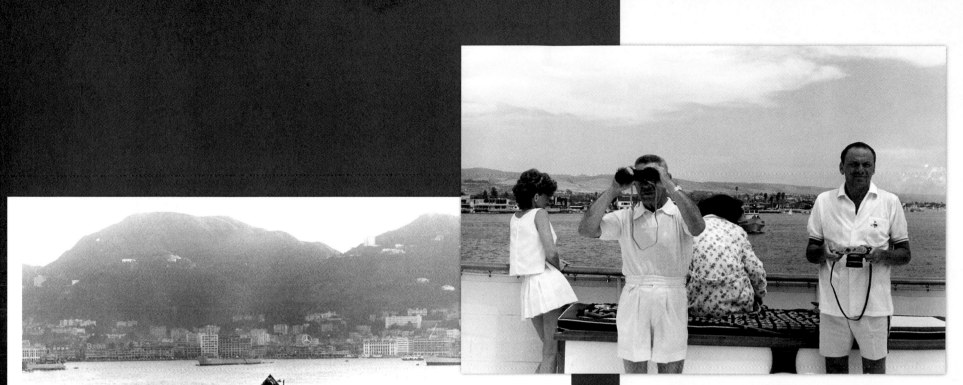

Frank with friend Mike Romanoff sightseeing during Sinatra's 1962 World Tour.

A Sinatra photograph in Hong Kong.

Sinatra took these photos (left) during his 1962 World Tour for Children. He also paid for all of the tour expenses, saying that an "overprivileged adult ought to help underprivileged children." Frank performed in Hong Kong, Tokyo, Rome, Paris, London, and Tel Aviv, among other places.

Jimmy Van Heusen wrote the music to many of Sinatra's hit songs, including "Come Fly With Me."

"Frank and Jimmy were the best of friends. They really enjoyed each other's company. Anytime they got together you were sure it was going to be exciting, and you were in for a long night. Neither of them required much sleep. A few months after Jimmy passed away, Frank was asked to sing at a tribute for Jimmy. Frank was so sad, when he started to sing "I Thought About You," he just broke up; he was barely able to get through the song." —Angie Dickinson

Frank and Jimmy Van Heusen get ready to take flight in the mid-1960s.

The Sinatra family gathers in Las Vegas: Frank, Nancy Jr., Nancy Sr., Tina, and Frank Jr. "Dad loved Las Vegas.

He reminisced about the city until the day he died. Some of his happiest times were in Las Vegas." —Tina Sinatra

With daughter Nancy (left), Frank celebrates his parents', Marty and Dolly's, fiftieth wedding anniversary on January 9, 1963, in New Jersey.

"My mother was very modern in a sense and fairly ambitious. She went to nursing school and became a midwife. She was a troubleshooter. If there was a problem somewhere, in any one of the families, the first thing you heard was 'you better call Dolly.'" —Frank Sinatra

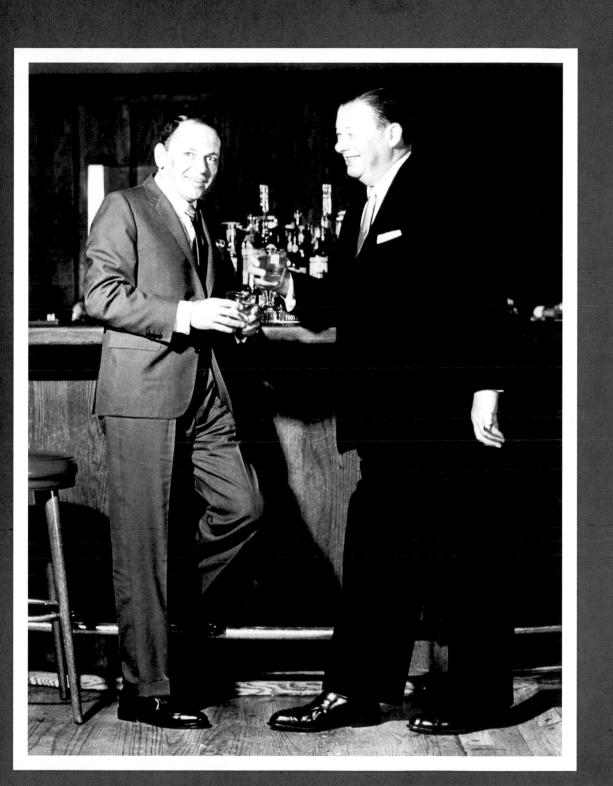

Sinatra having a drink with saloon owner Toots Shor in the mid-1960s.

For several decades, beginning in the 1940s, Toots Shor's restaurant, located at 51 West 51st in New York, was a popular hangout for many entertainers, writers, and sports figures.

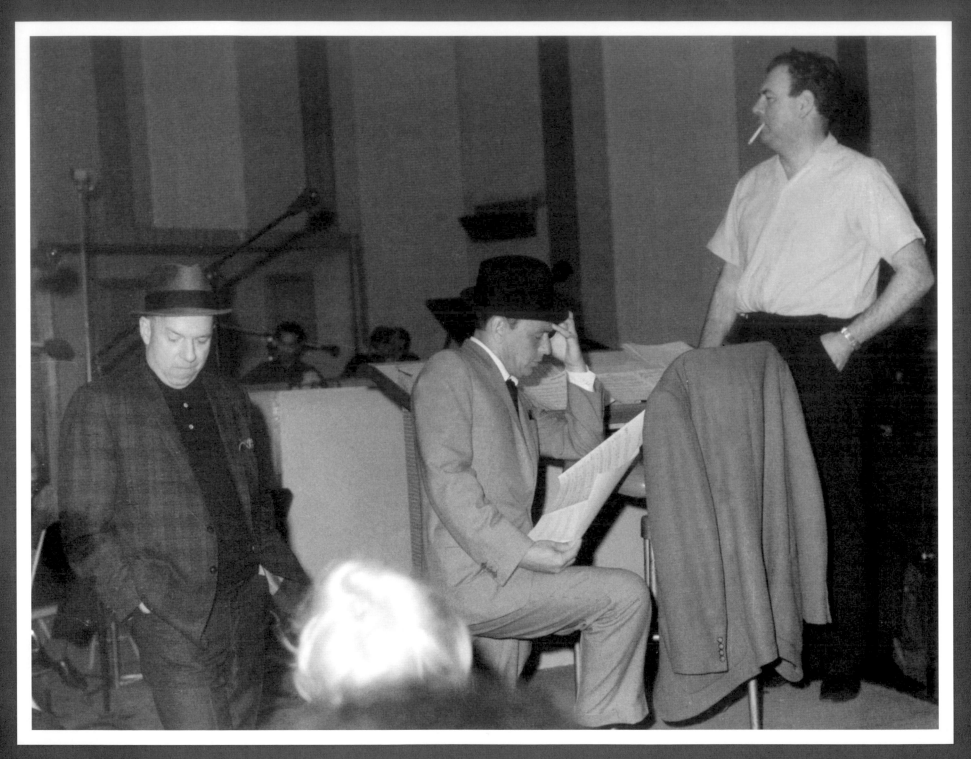

Sinatra looks over a lead sheet during a recording session in April 1964. Songwriter Jimmy Van Heusen (left) and arranger Nelson Riddle stand by.

Tony Bennett celebrating Sinatra's fiftieth birthday at the Beverly Wilshire Hotel, December 12, 1965. "When Frank sings a song, he wraps himself around it and sinks himself into it. You can just feel every syllable and you know his soul is in it. Sinatra leaves behind a legacy of music, a legacy that will live forever. Five hundred years from now, people will still be listening to his recordings and they'll say, 'There was only one Sinatra.' And that's not an opinion, it's a fact." —Tony Bennett

Joe E. Lewis entertains guests at Nancy Jr.'s twenty-fifth birthday celebration at Chasen's, June 1965.

"He was never bored, never blasé about anything. There is nothing I can think of that he was blasé about, nothing. He approached music with that same energy, that same vivacity, that same attack. There was a zest for living, there was zest for music, and there was a zest for doing a crossword puzzle."

—Nancy Sinatra Jr.

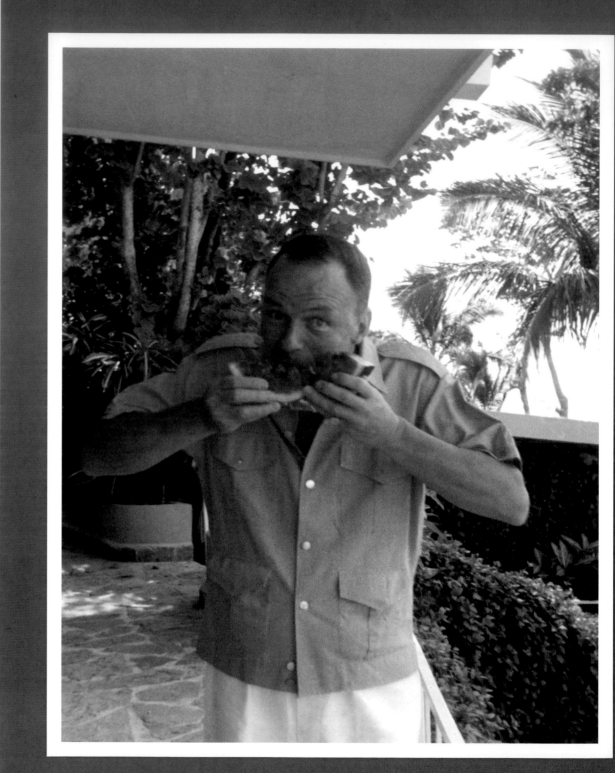

Enjoying a piece of watermelon at his Palm Springs home in 1965.

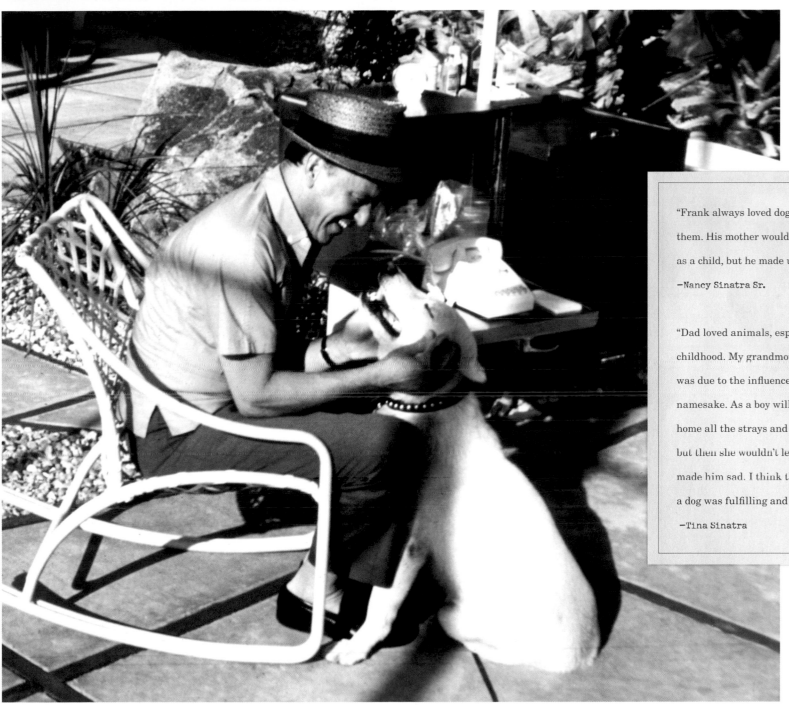

"Frank always loved dogs and had several of them. His mother would never let him have one as a child, but he made up for that later in life."
—Nancy Sinatra Sr.

"Dad loved animals, especially dogs, since childhood. My grandmother used to say it was due to the influence of St. Francis, his namesake. As a boy will, Dad would bring home all the strays and Dolly would feed them, but then she wouldn't let him keep them, which made him sad. I think the unconditional love of a dog was fulfilling and very calming for him."
—Tina Sinatra

Frank with one of his dogs at home in Palm Springs, California, 1964.

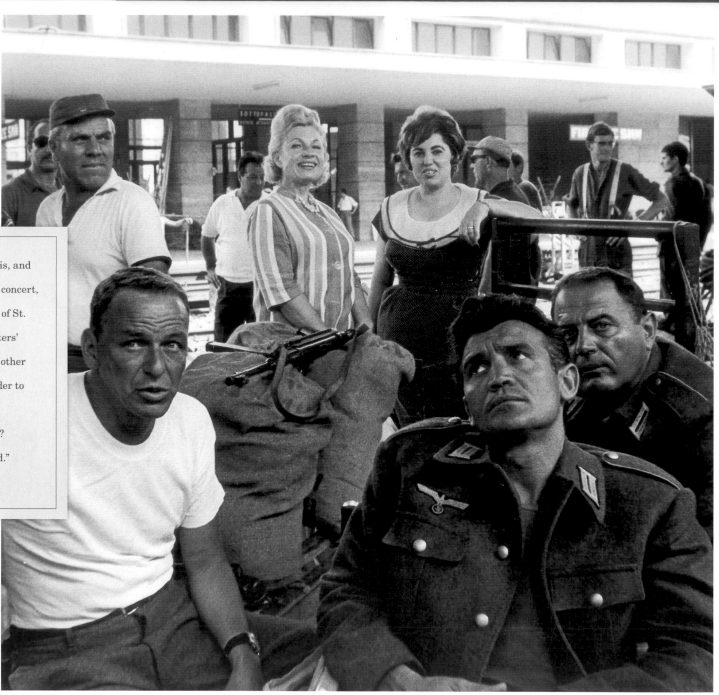

(far right) Dean Martin, Sammy Davis, and Johnny Carson joined Sinatra for this concert, which was a benefit for Dismas House of St. Louis, a favorite charity of the Teamsters' Union. The concert was also shown in other cities on closed circuit television in order to raise more funds.

"How can I explain Frank Sinatra? He's the best pop singer that ever lived."

–Quincy Jones

Frank on the set of *None But the Brave* with fellow actors Dick Bakalyan (center) and Brad Dexter. The film would mark Sinatra's directorial debut.

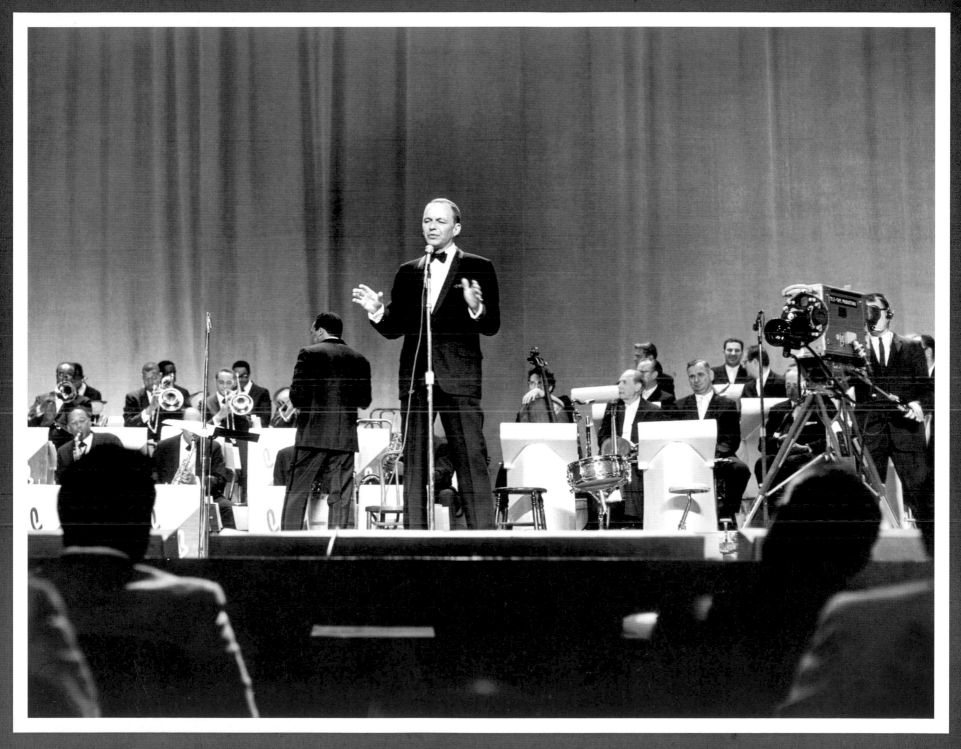

Frank swings with the Count Basie Orchestra conducted by Quincy Jones at the Kiel Auditorium on June 20, 1965.

Ringside for a Sinatra performance at the Sands, Las Vegas, February 1965: Nancy Sr., Yul Brynner and his wife, Doris Kleiner, Jack Entratter (standing), Edward G. Robinson (with beard) and his wife, Jane Robinson, and Leo Durocher. (seated at right) Nancy Jr., Tommy Sands and Mike Romanoff.

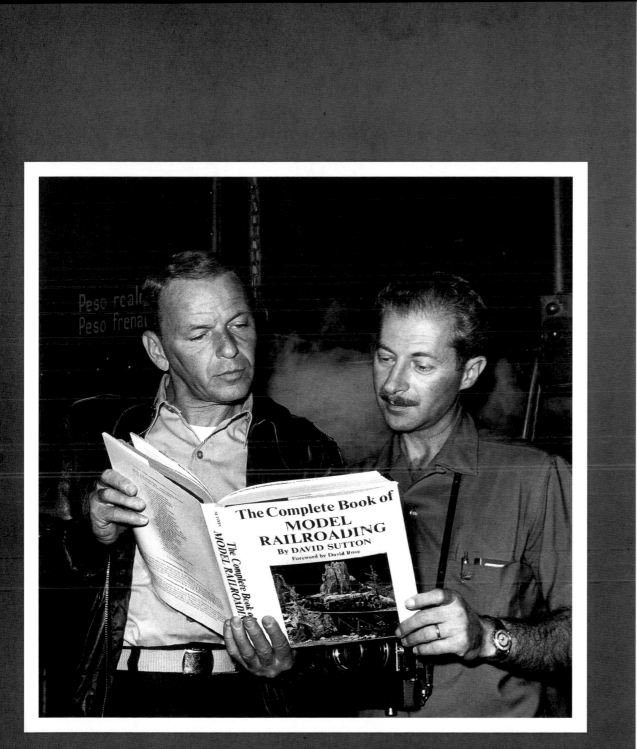

Frank and photojournalist David Sutton, both model railroad enthusiasts,
look over a book about trains on the set of *Von Ryan's Express* in 1965.

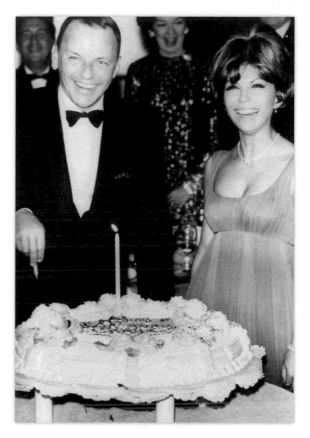

Celebrating his fiftieth birthday, Sinatra gets
ready to cut the cake with daughter Nancy.

(above) The birthday party, thrown by Nancy
Sinatra Sr., was held at the Beverly Wilshire
Hotel. Sammy Davis Jr. popped out of a giant
birthday cake to surprise Frank.

...

(left) "David [Sutton] is the best of the best.
When you see his photos you'll know what I
mean." —Frank Sinatra

Frank and Nancy at Western Recorders during the session for their hit song "Somethin' Stupid."

"On the first take, Dad got silly, sounding his S's like Daffy Duck for fun, so we had to do a second take. Mo Ostin, the president of Reprise, bet him two dollars it would bomb. He lost his money. The song went to number one, selling several million copies." —Nancy Sinatra Jr.

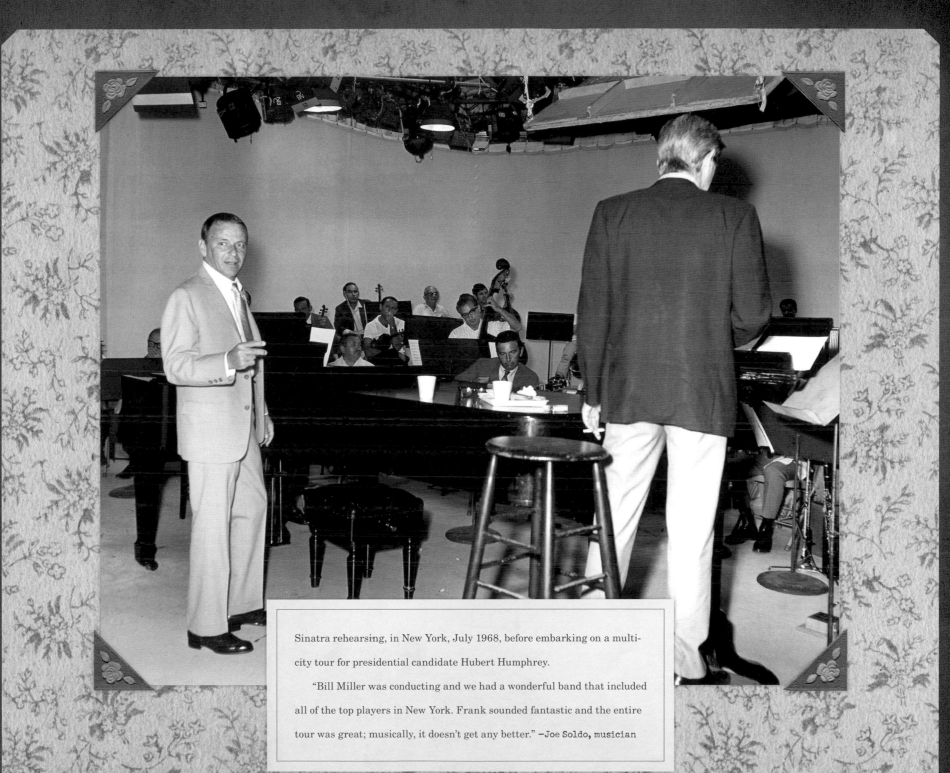

Sinatra rehearsing, in New York, July 1968, before embarking on a multi-city tour for presidential candidate Hubert Humphrey.

"Bill Miller was conducting and we had a wonderful band that included all of the top players in New York. Frank sounded fantastic and the entire tour was great; musically, it doesn't get any better." —Joe Soldo, musician

Frank runs down a song with arranger Don Costa before a recording session in 1969.

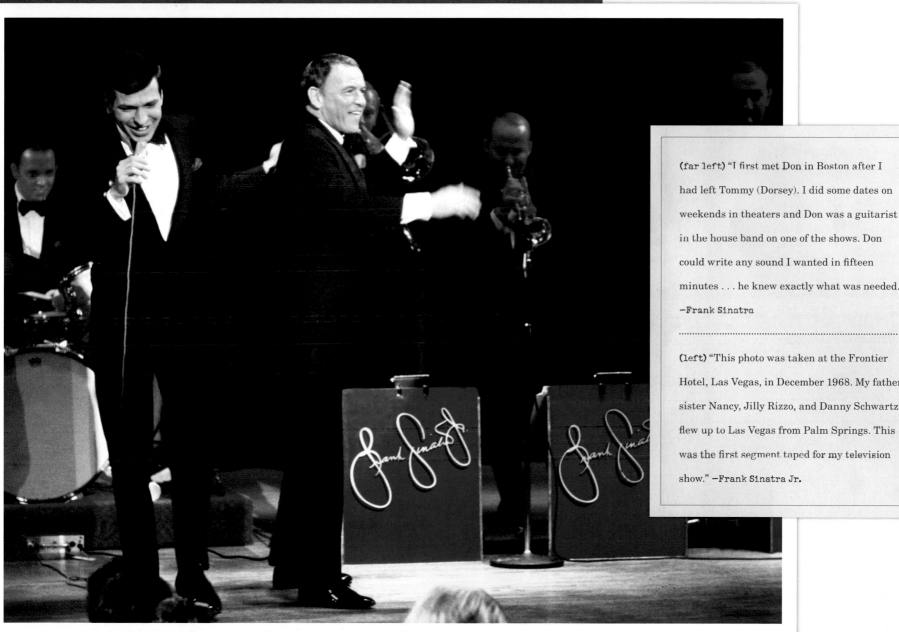

(far left) "I first met Don in Boston after I had left Tommy (Dorsey). I did some dates on weekends in theaters and Don was a guitarist in the house band on one of the shows. Don could write any sound I wanted in fifteen minutes . . . he knew exactly what was needed." —Frank Sinatra

(left) "This photo was taken at the Frontier Hotel, Las Vegas, in December 1968. My father, sister Nancy, Jilly Rizzo, and Danny Schwartz flew up to Las Vegas from Palm Springs. This was the first segment taped for my television show." —Frank Sinatra Jr.

The Sinatra men sing "All or Nothing At All" for the special *Frank Sinatra Jr. and his Family and Friends*.

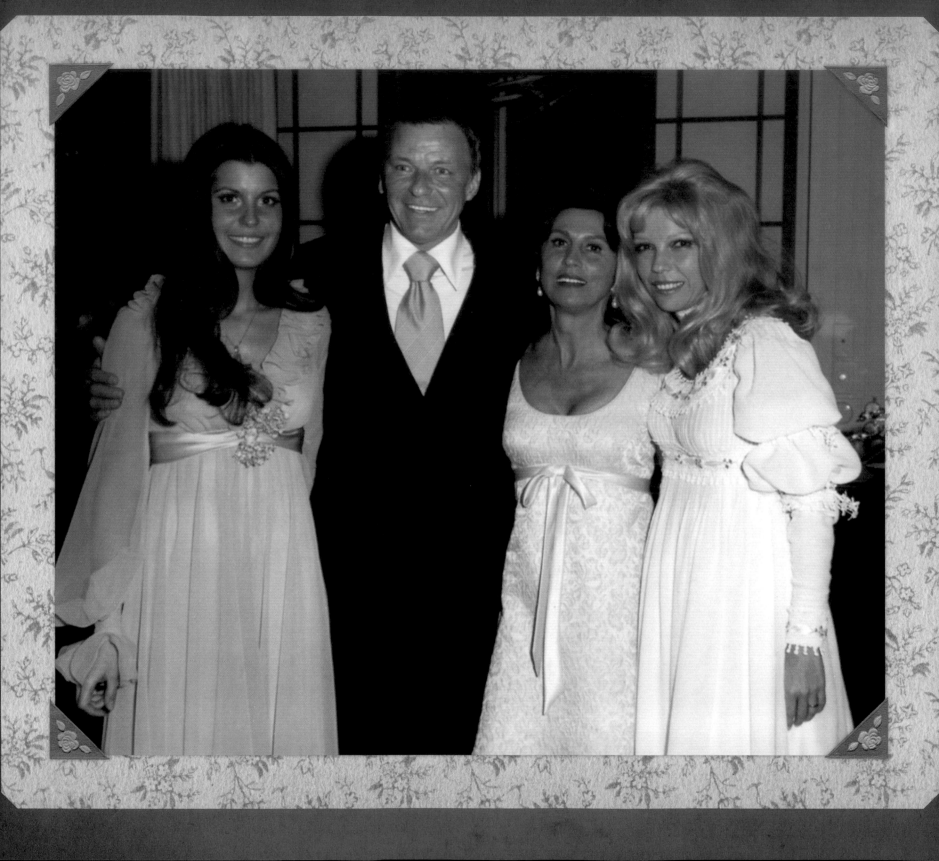

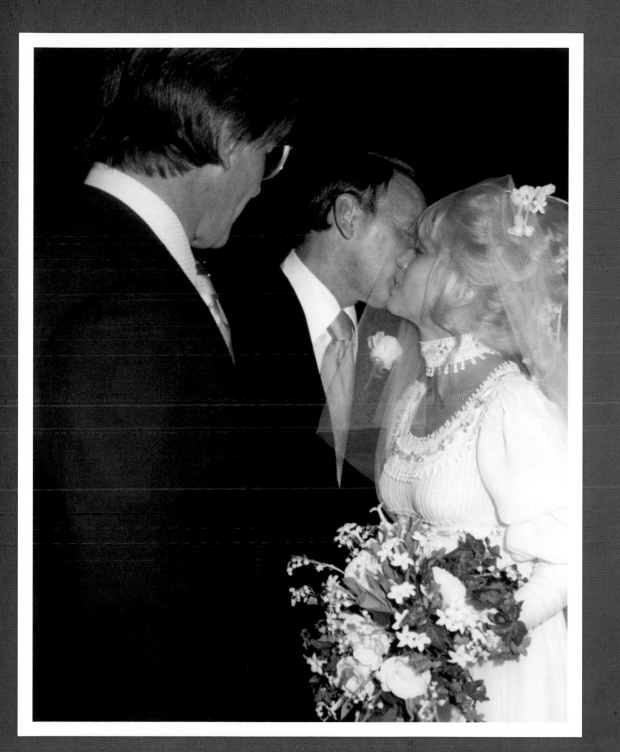

Sinatra kisses daughter Nancy on her wedding day, as husband Hugh Lambert looks on, December 12, 1970—also Frank's fifty-fifth birthday.

(far left) Tina, Frank, Nancy Sr., and Nancy Jr., pose on Nancy Jr.'s wedding day.
(left) "I felt closer to Dad after he gave me away than ever before. He seemed more introspective, but at the same time more relaxed." —Nancy Sinatra Jr.

The Legend

1971–1998

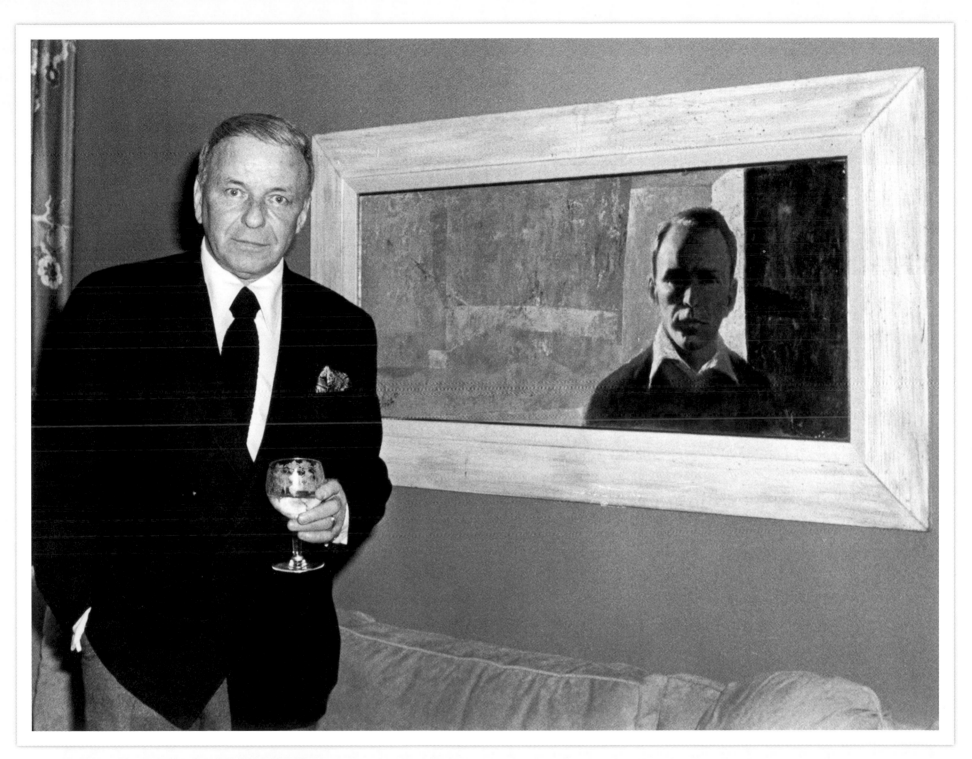

Frank stands next to a portrait of himself at his home. The portrait was used as the cover art for his 1962 album *All Alone*.

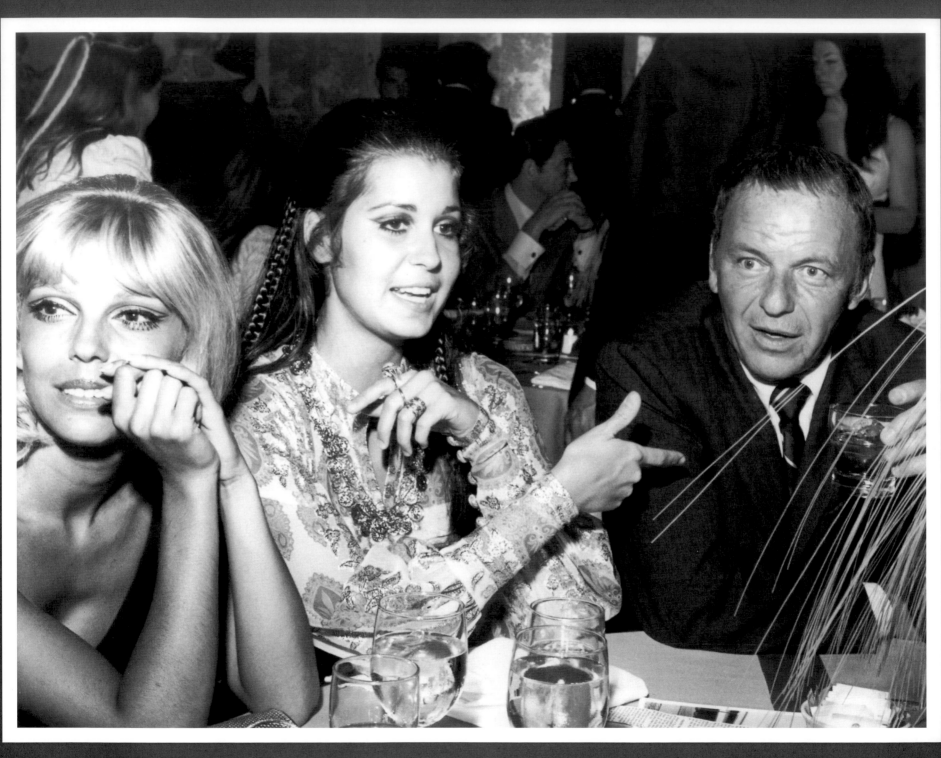

Nancy, Tina, and Frank enjoying an evening out together.

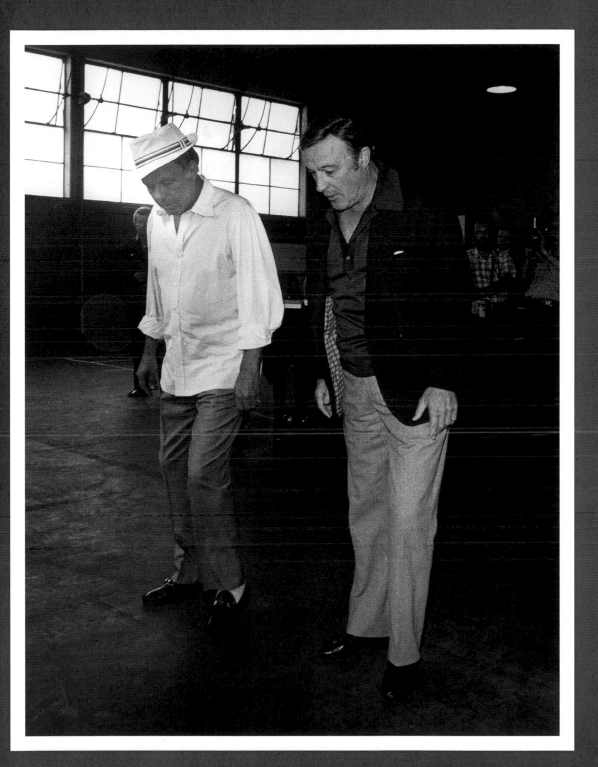

Sinatra and Gene Kelly rehearsing a dance number for the television special *Ol' Blue Eyes Is Back* in 1973.

Frank and Gene Kelly starred in several musicals together, such as *Anchors Aweigh*, *On the Town*, and *Take Me Out to the Ball Game*.

"When MGM paired us together Frank really wanted to learn to dance, that's what he told me. I said 'OK.' He said, 'Let's go,' and he trained like a fighter. He rehearsed and rehearsed until we got everything the way we wanted it. Mainly we had fun; we always had fun." –Gene Kelly

"I had two left feet but Gene taught me to dance. When I saw the rushes one day of the first time that we had done something together my eyes were this big; I couldn't have been happier." –Frank Sinatra

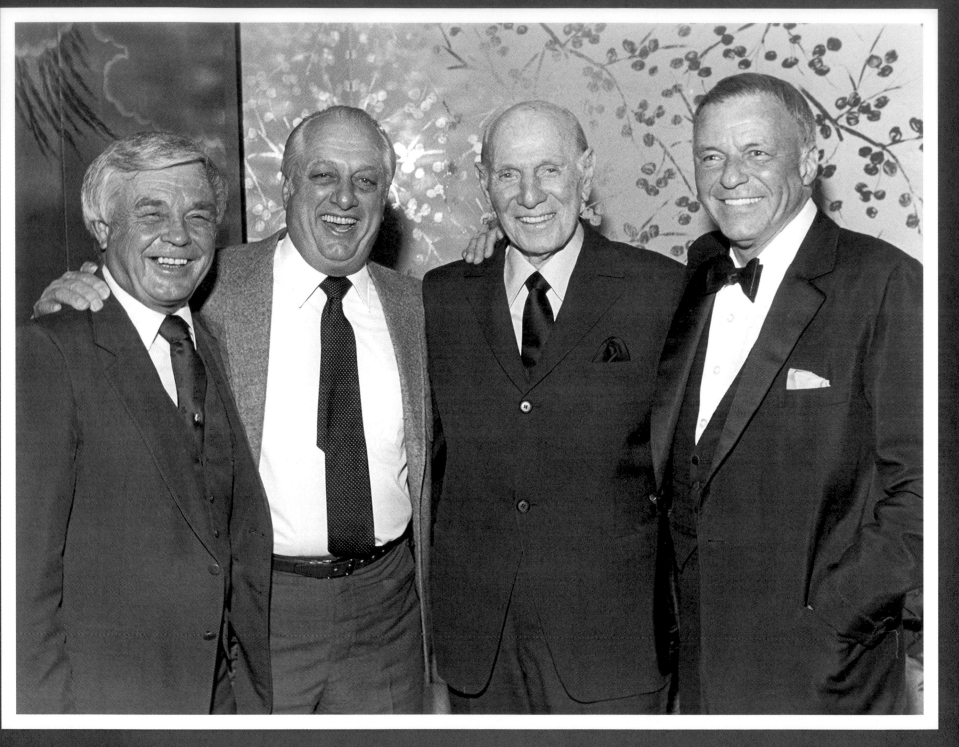

Three of baseball's most famous managers—Earl Weaver, Tommy Lasorda, and Leo Durocher—visit Frank backstage after one of his concerts.

Dean, Steve Wynn, and Frank.

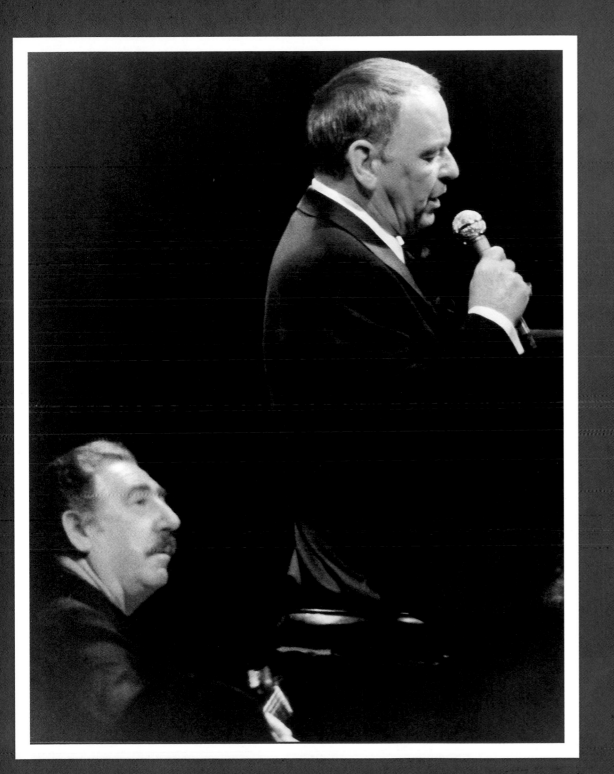

Sinatra singing "Send In The Clowns," accompanied by guitarist Al Viola, March 1979.

(above) Dean Martin, Golden Nugget chairman Steve Wynn, and Frank take a break while filming a commercial for the Golden Nugget Hotel & Casino.

..

(left) "I was fortunate because I worked with Frank in the 1940s, 1950s, 1960s, 1970s, and 1980s. As a musician, you can't ask for more, but you know what, working and knowing Frank also made me a better person. For that, I will love him 'till the day I die." —Al Viola

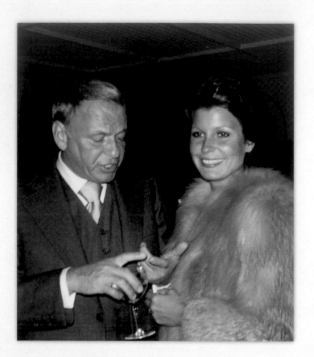

Frank and daughter Tina at a family
function. (Tina's furs are long gone.)

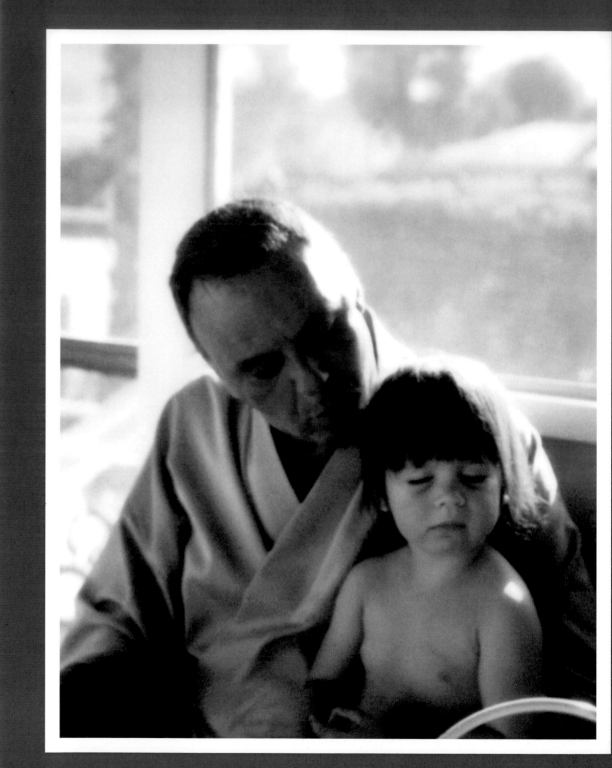

Ol' Blue Eyes meets Baby Blue Eyes. Frank with his first granddaughter, Angela Jennifer Lambert, at his Palm Springs home.

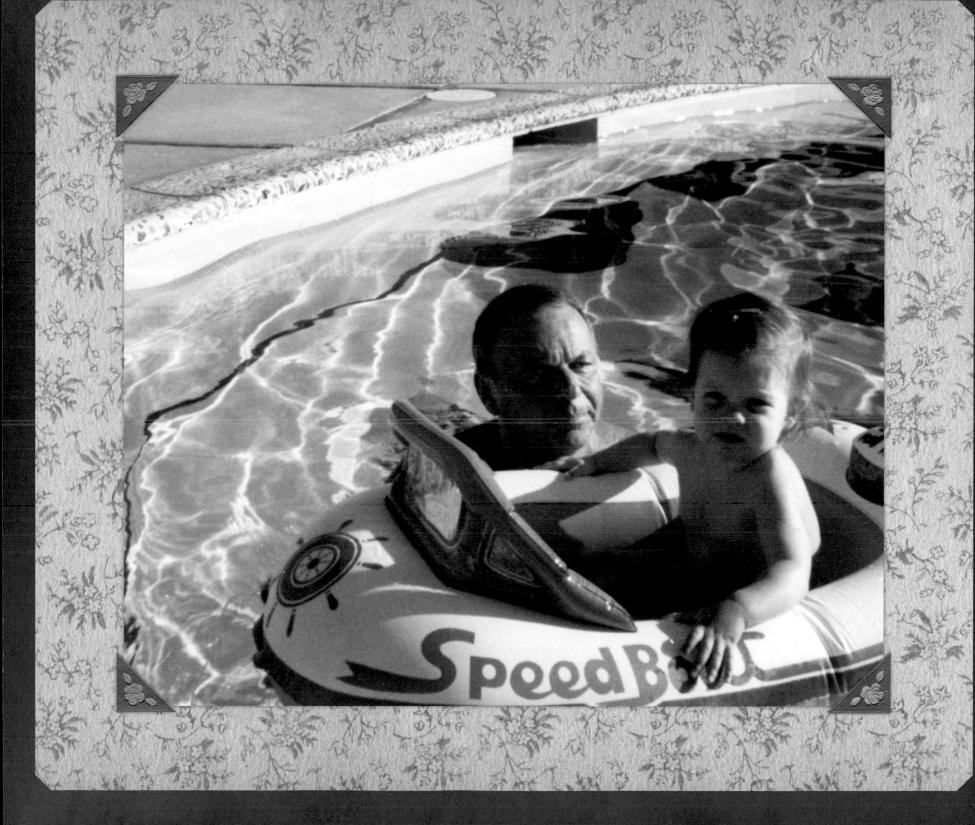

Sinatra and son, Frank, share a laugh at a family function.

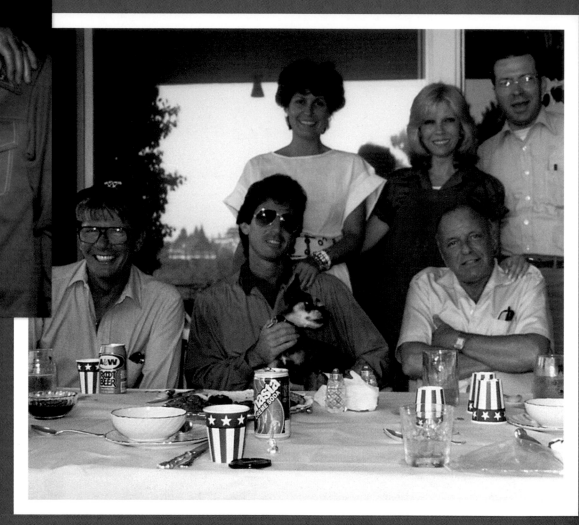

Seated, left to right: Hugh Lambert, Bob Finkelstein, and Frank. Standing: Tina, Nancy, and Frank Jr.

(right) The Sinatra family celebrating the

Fourth of July holiday.

Sinatra with his mother, Dolly, in the summer of 1976.

"My mother influenced me a great deal. She was a self-taught woman, very bright, had good common sense and was a hard worker. She was the force!" —Frank Sinatra

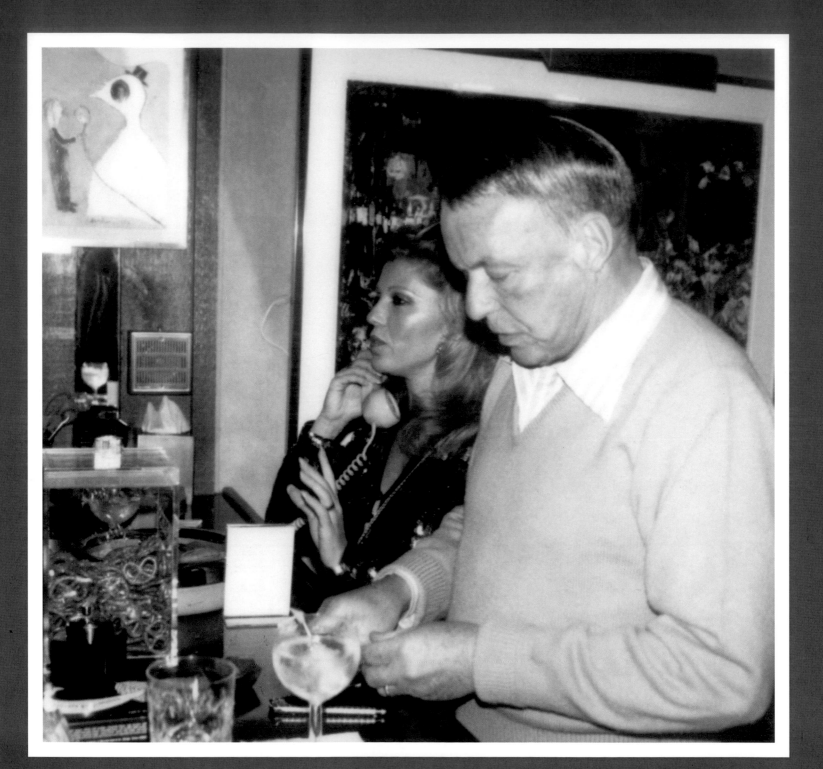

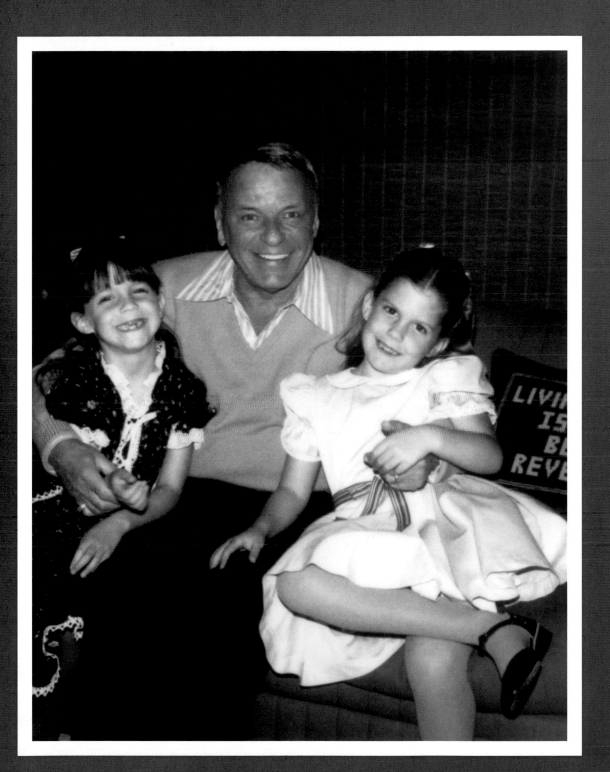

(above and right) Frank with granddaughters A.J. and Amanda at his home in Palm Springs.

"Me and my sister with my grandfather at his Palm Springs home. We would always sit with him in his den before dinner. He was usually watching *Jeopardy!*—he loved *Jeopardy!*."
—Amanda Erlinger

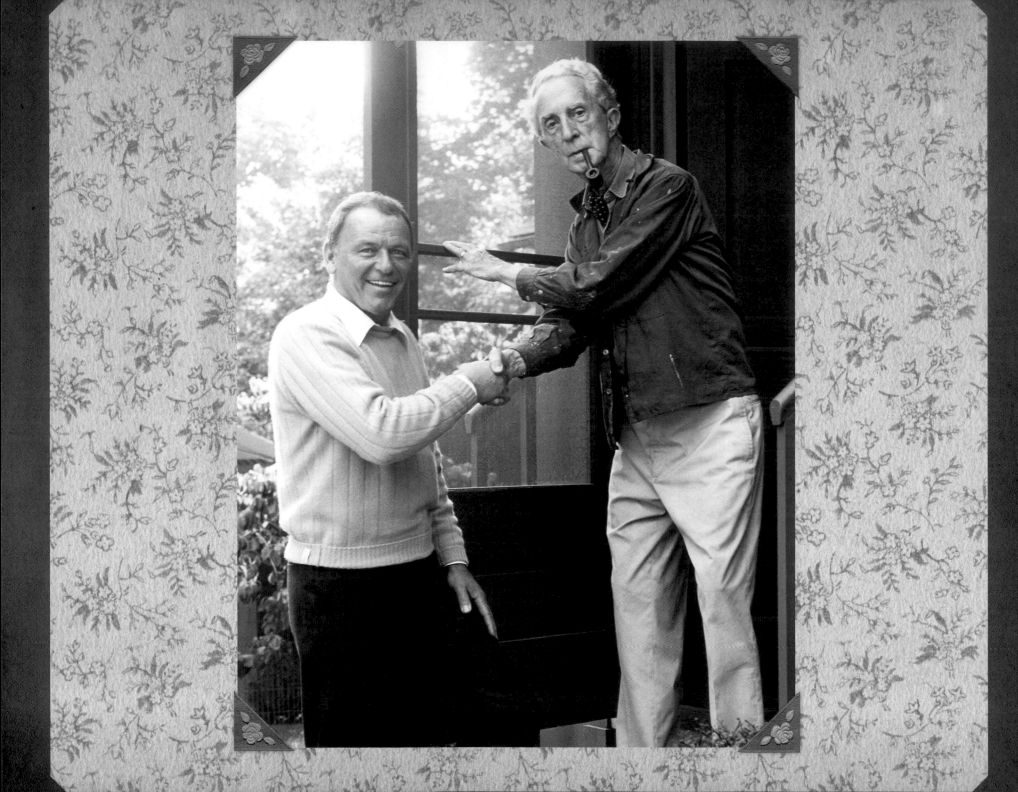

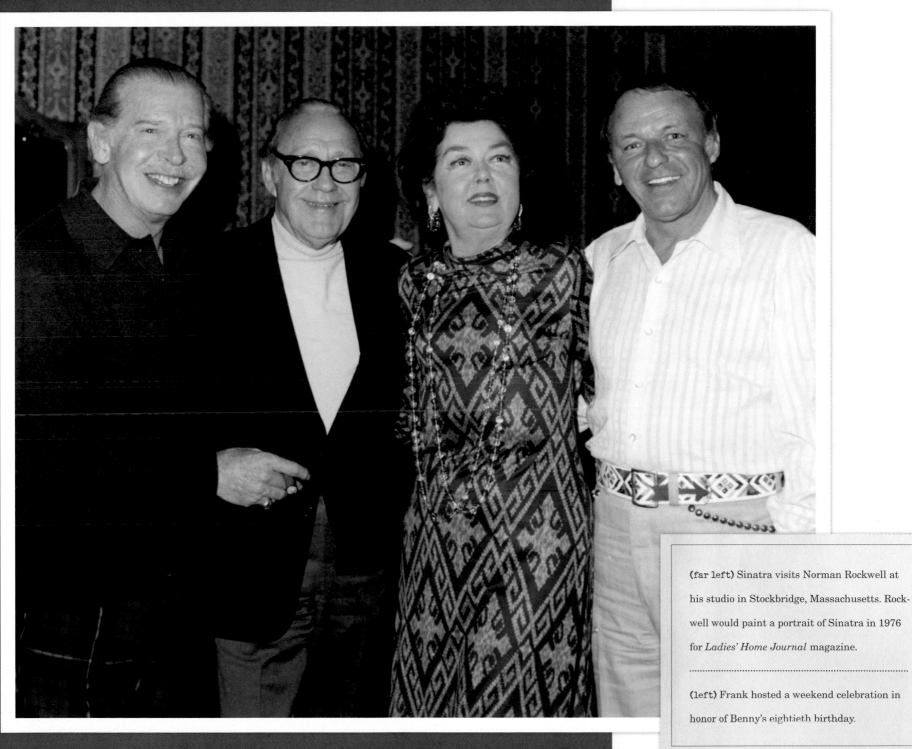

Milton Berle, Jack Benny, and Rosalind Russell with Sinatra at his Palm Springs home in February 1973.

(far left) Sinatra visits Norman Rockwell at his studio in Stockbridge, Massachusetts. Rockwell would paint a portrait of Sinatra in 1976 for *Ladies' Home Journal* magazine.

..

(left) Frank hosted a weekend celebration in honor of Benny's eightieth birthday.

Sinatra performed for a White House dinner President Nixon was hosting in honor of Giulio Andreotti, the prime minister of Italy.

"Once in a while there is a moment when there is magic in the room, when a singer is able to move us and capture us all. Frank Sinatra has done that tonight." —Richard Nixon

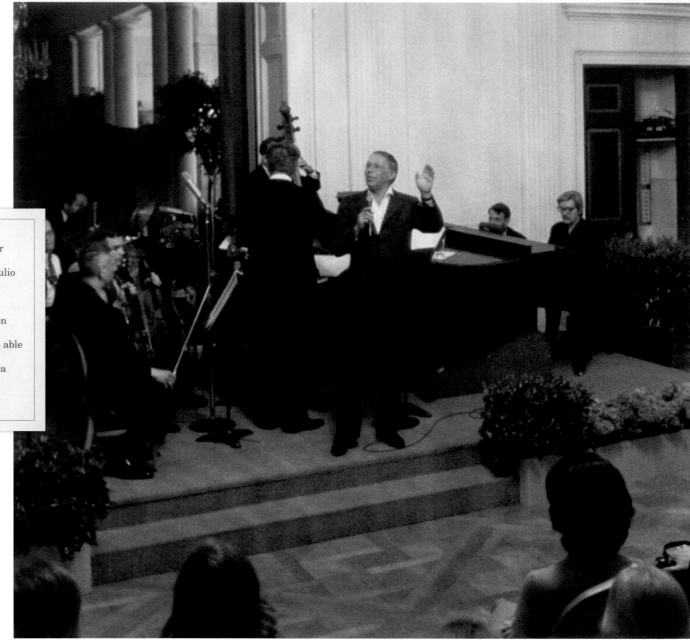

Frank invited the White House staff to attend his afternoon rehearsal on April 17, 1973.

Returning to perform at Carnegie Hall for the first time since 1963, Frank began a tour to assist Variety Clubs International on April 8, 1974, to protect homeless, abused, and orphaned children.

"When it came to donating his time or money, I learned never to question it. Once Frank had made up his mind that was that. He was the most generous client I ever worked for. I can't tell you the thousands of checks I sent over the years to strangers. Frank would read or hear about someone in trouble or in need and had me send him or her a check—anonymously. When it came to giving, he was in a league of his own." —Sonny Golden, Sinatra's business manager

Sinatra and Sarah Vaughn rehearsing a number with Bill Miller conducting the Count Basie Orchestra. The trio of Sinatra, Count Basie, and Sarah Vaughn played to record crowds at the London Palladium in November 1975.

"I remember Frank calling me before he arrived to inquire how the tickets sales were going. I told Frank, 'If you would like, you can play the Palladium for an entire year, maybe more!' " —Harold Davison, promotor

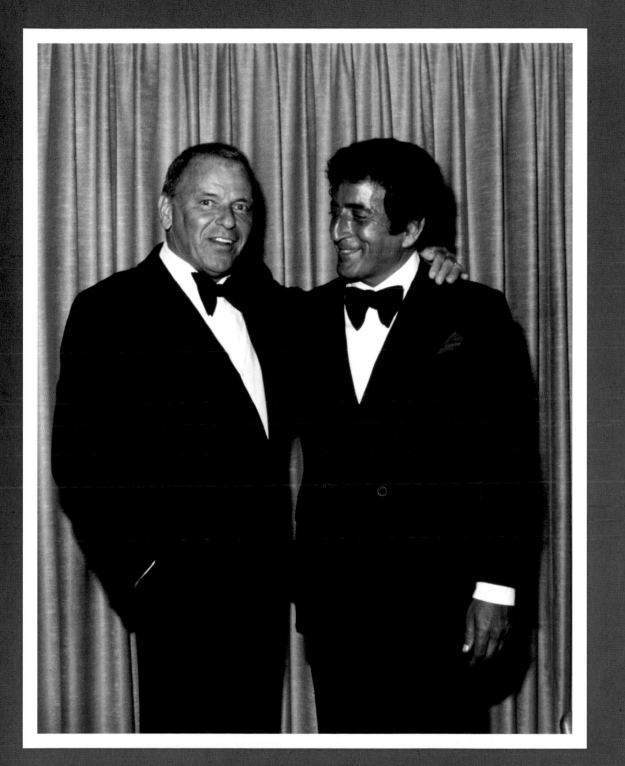

Tony Bennett backstage after seeing Sinatra perform at Harrah's Lake Tahoe in 1977.

"For my money, Tony Bennett is the best singer in the business, the best exponent of a song. He excites me when I watch him he moves me. He's the singer who gets across what the composer has in mind, and probably a little more. There's a feeling in back of it."
—Frank Sinatra, 1965

"My life changed as a result of Sinatra. In 1965, when he paid me that compliment in *Life* magazine, it really changed my whole life. He was wonderful to me. Every time I read or hear that quote I'm moved by it. Sinatra had a magnificent gift; in popular music he had the best musical sound; a sound that was very honest, just a golden voice. He was my best friend in show business. I miss him."
—Tony Bennett

Sammy Davis Jr. (left) looks on as Sinatra celebrates
Nancy's and Tina's birthdays at Chasen's .

(right and far right) Frank, Dean Martin,
and Sammy Davis Jr. entertain the crowd
at Chasen's restaurant during a birthday
party for Tina, Nancy Jr., and Dean Martin,
June 8, 1978.

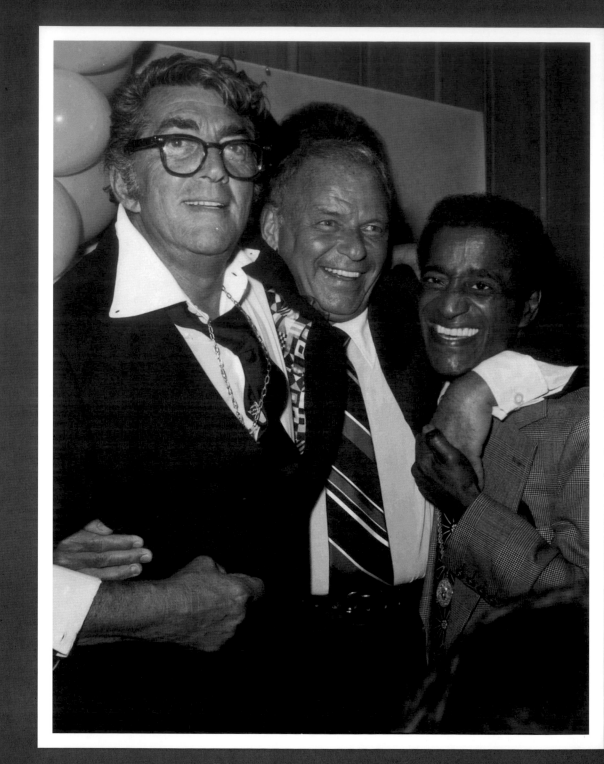

"We love each other, the three of us." –Dean Martin

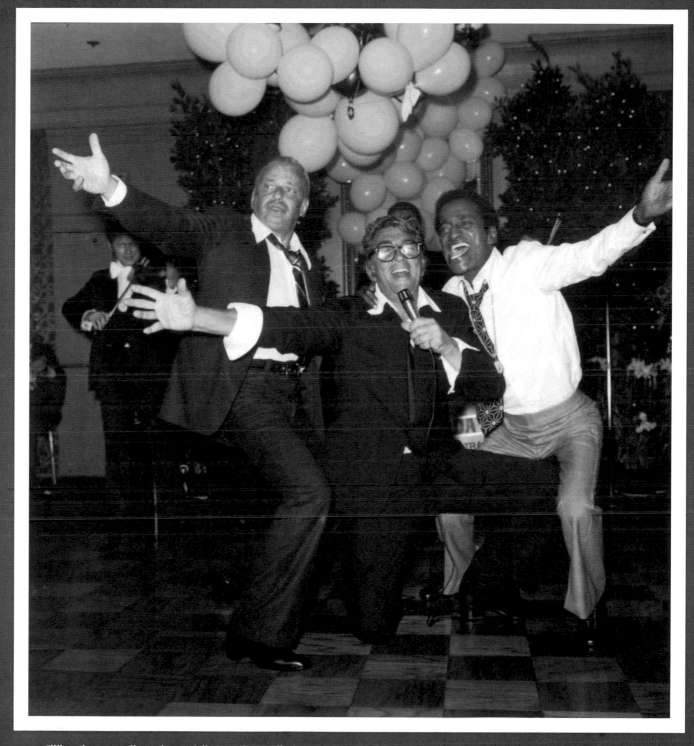

"When they were all together, socially or professionally, it was magic. They really loved each other being with each other." —Tina Sinatra

Frank Sinatra served as the Grand Marshal of the Columbus Day Parade in New York City on October 8, 1979, thirty-five years after he caused the Columbus Day riots at the Paramount Theatre. Governor Hugh Carey (behind Sinatra right) and Jilly Rizzo (far right) walk along with Sinatra.

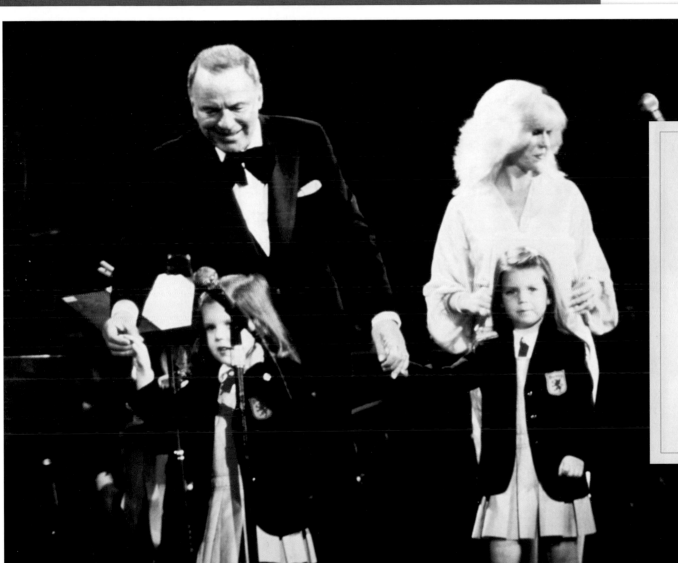

Frank Sinatra is joined on stage by granddaughters Amanda and A.J. and daughter Nancy as he celebrates his fortieth anniversary in show business at the Universal Amphitheatre—June 13, 1979.

"My sister and I were on stage in our school uniforms because the concert was a benefit for our school. This was my worst nightmare as a child. I hated to be up on stage. I was terrified; I cried and cried. After that, my mom never put me on stage again."

—Amanda Erlinger

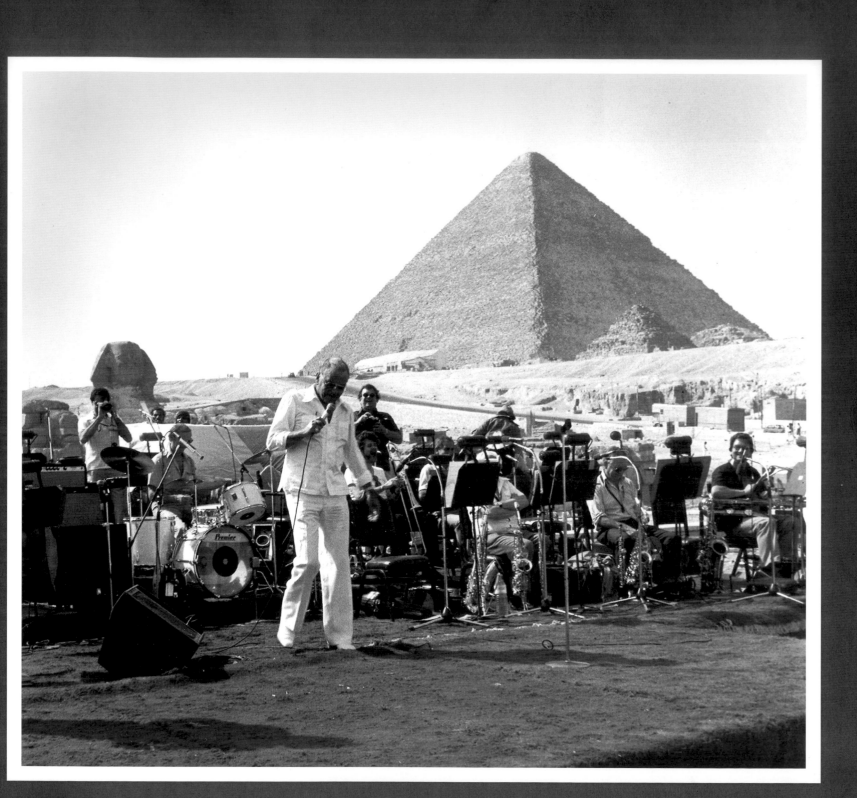

Frank rehearses for a benefit concert at the foot of the great pyramids in Giza in September 1979. "This is the biggest room I've ever played," he quipped.

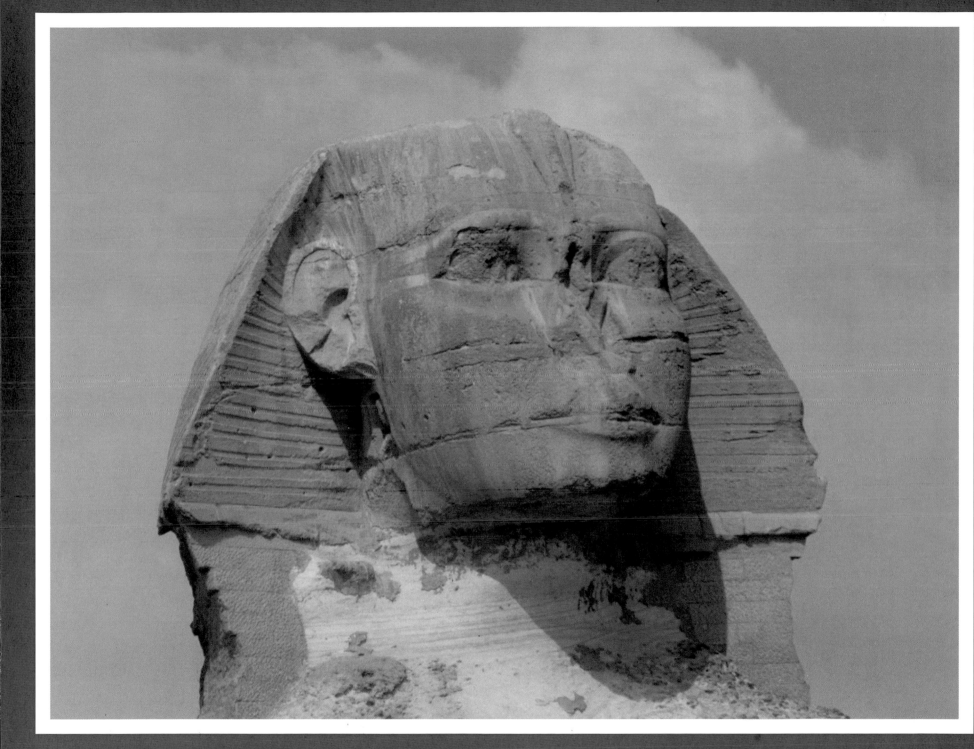

Frank took this picture of the Sphinx while in Egypt for the 1979 benefit concert.

Rich Little, Bob Hope, Johnny Carson, Sinatra, and Ben Vereen take a break during rehearsals for the Inaugural Gala for President-elect Ronald Reagan. Sinatra served as producer for the Gala in January 1981, as he would again in January 1985, when President Reagan began to his second term.

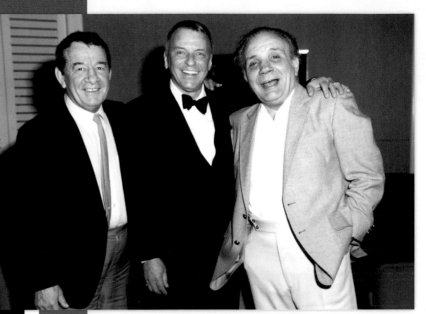

The Chairman and the Champs: Rocky Graziano and Jake LaMotta greet Sinatra backstage after a concert in 1981.

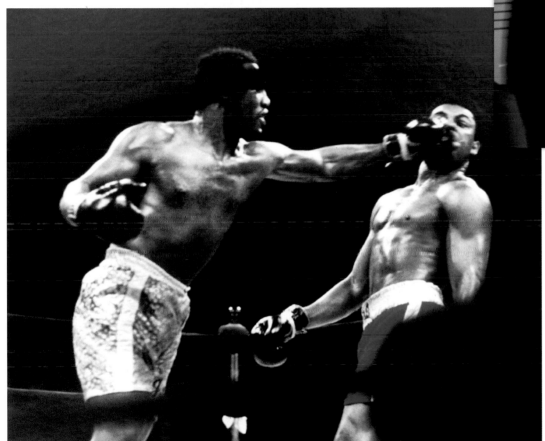

Sinatra, a huge boxing fan, attended many boxing matches throughout his life and had an extensive collection of championship fights on film.

(left) *Life* magazine assigned Frank to photograph the first Muhammad Ali–Joe Frazier bout, the "Fight of the Century." This is one of the photos that Frank took that evening at Madison Square Garden on March 8, 1971.

Sinatra, Joe Malin, Sid Cooper, and Jilly Rizzo look over a plaque to commemorate Sinatra's recent tour of South Africa and Brazil. This photo was taken in Atlantic City during an August 24, 1981, rehearsal at Resorts International.

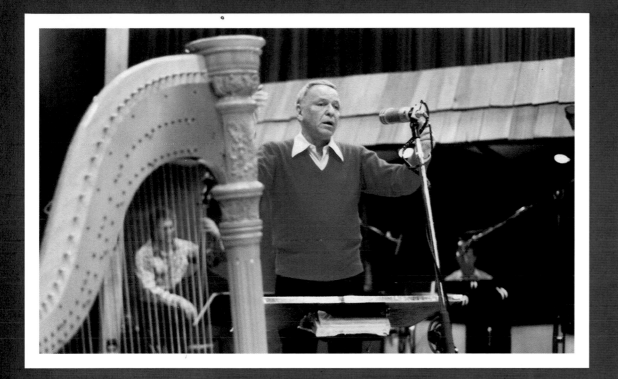

Sinatra relaxes between the early and late shows at Resorts International, Atlantic City, in April 1981.

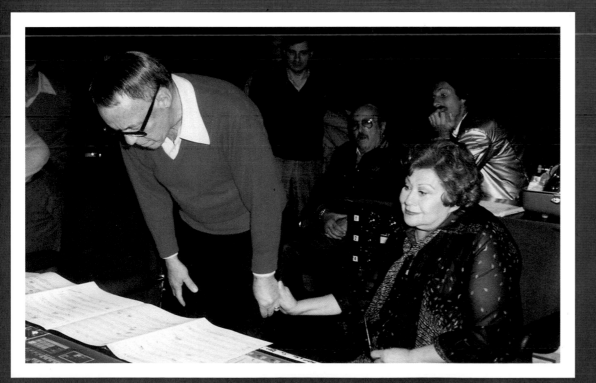

Frank conducted and produced the album *Syms by Sinatra* for his friend Sylvia Syms. These photos are from a recording session at Columbia Studios, New York, in April 1982.

"This album was a culmination of a dream."
—Sylvia Syms

Frank rehearsing during his April 1982 engagement at Resorts International, Atlantic City, New Jersey. Tony Mottola, guitarist, and Bernie Leighton, pianist, are also pictured.

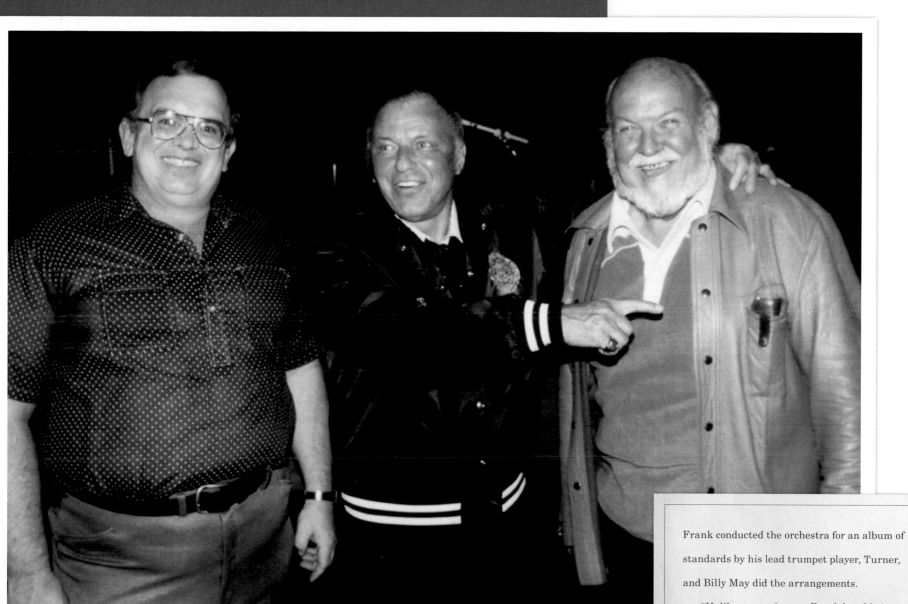

Charles Turner (left), Frank, and Billy May at Evergreen Studios, Burbank, California, on January 3, 1983.

Frank conducted the orchestra for an album of standards by his lead trumpet player, Turner, and Billy May did the arrangements.

"Unlike many singers, Frank loved being around the musicians; he was one of us."
—Billy May

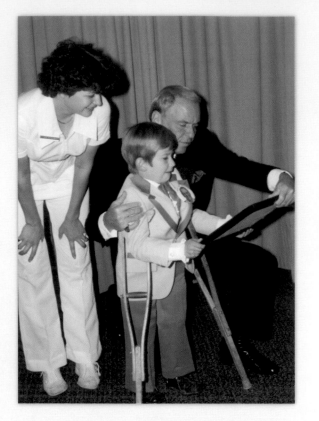

Frank receives an award before a concert in Denver
to benefit the Juvenile Diabetes Foundation.

"Unless it was impossible for him to do, for various
reasons, Frank never turned down a benefit that
involved helping children—never!"
—Sonny Golden

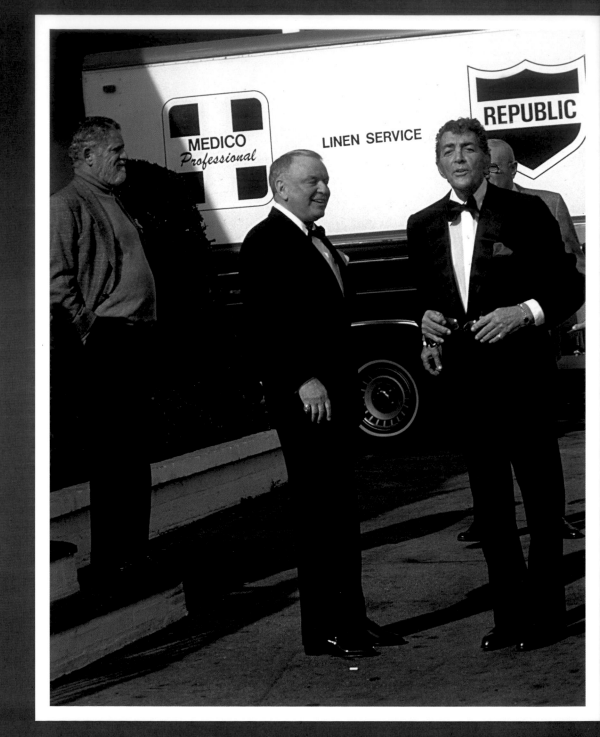

Sonny Golden, Sinatra, Dean, and Jilly Rizzo (behind Martin) outside
Chasen's Restaurant in Beverly Hills before a press conference.

The marquee from Bally's Las Vegas. "To be in Las Vegas with Sinatra was surreal, even the audience sensed that; it was his town. I first worked Vegas with Frank at the Golden Nugget in 1984. To go to Las Vegas and work with Sinatra is hard to describe, because Frank Sinatra was Las Vegas. I'd have to compare it to going to heaven with Jesus." —Tom Dreesen

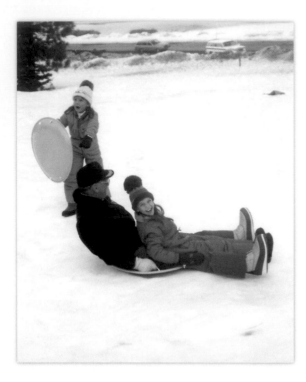

"We had a great time in the snow with my grandfather. He rented the saucer sleds and we went flying down the hills with him. He was in a great mood, and we laughed a lot on that trip." —Amanda Erlinger

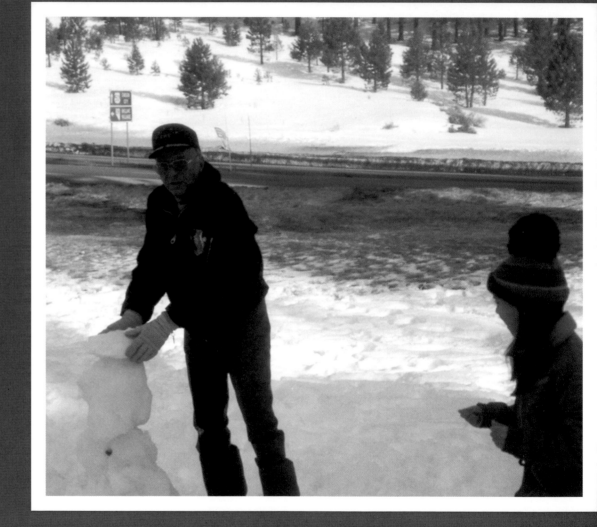

(left and above) Sinatra and granddaughters A.J. and Amanda enjoy the snow in Lake Tahoe, January 1983.

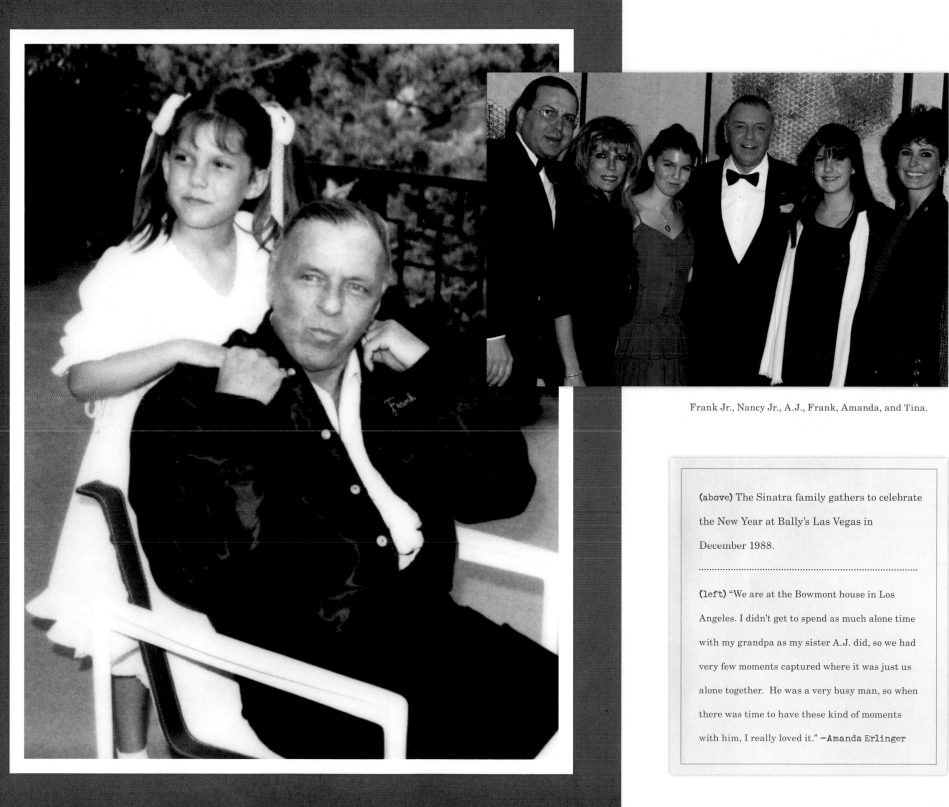

Frank Jr., Nancy Jr., A.J., Frank, Amanda, and Tina.

(above) The Sinatra family gathers to celebrate the New Year at Bally's Las Vegas in December 1988.

..

(left) "We are at the Bowmont house in Los Angeles. I didn't get to spend as much alone time with my grandpa as my sister A.J. did, so we had very few moments captured where it was just us alone together. He was a very busy man, so when there was time to have these kind of moments with him, I really loved it." —Amanda Erlinger

Frank Sinatra along with his third cousin, Herman, and son Frank, backstage before a concert at the Niagara Falls Civic Arena, May 12, 1990.

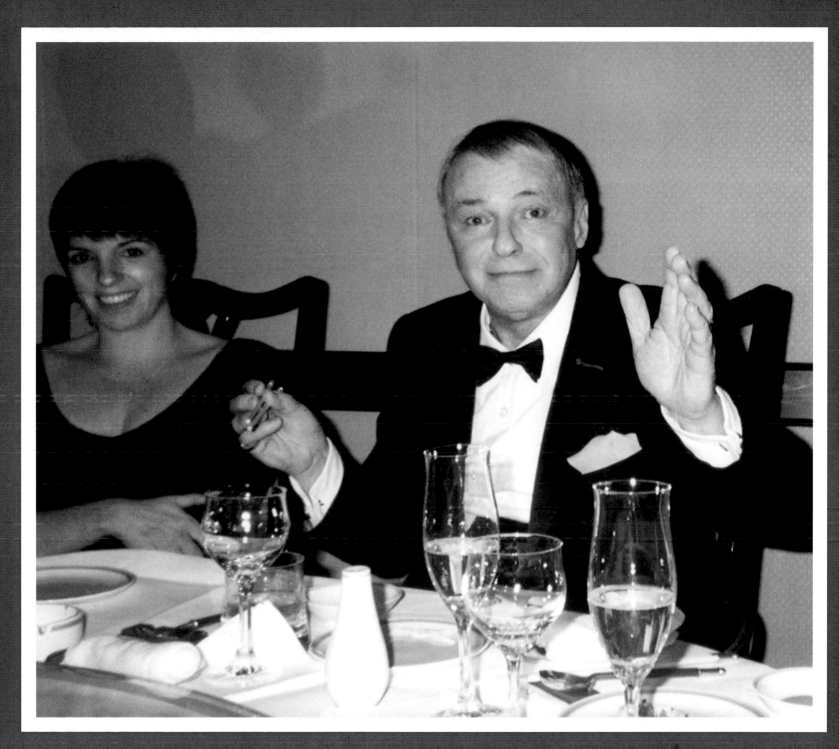

Sinatra waves to the camera while dining in Japan after a concert; Liza Minnelli is seated next to him.
This photo was taken in February 1989, during "The Ultimate Event" tour, which also included Sammy Davis Jr.

Backstage at the Bally Grand in Atlantic City, New Jersey, entertainment director Bobby Young presents Sinatra with a model train as Jilly Rizzo looks on. Sinatra was an avid train collector. "I had an uncle who was an electrician and he bought me the first train I ever had . . . He put it up around the (Christmas) tree with the transformer; it was an engine with about three cars and I was fascinated from then on." —Frank Sinatra

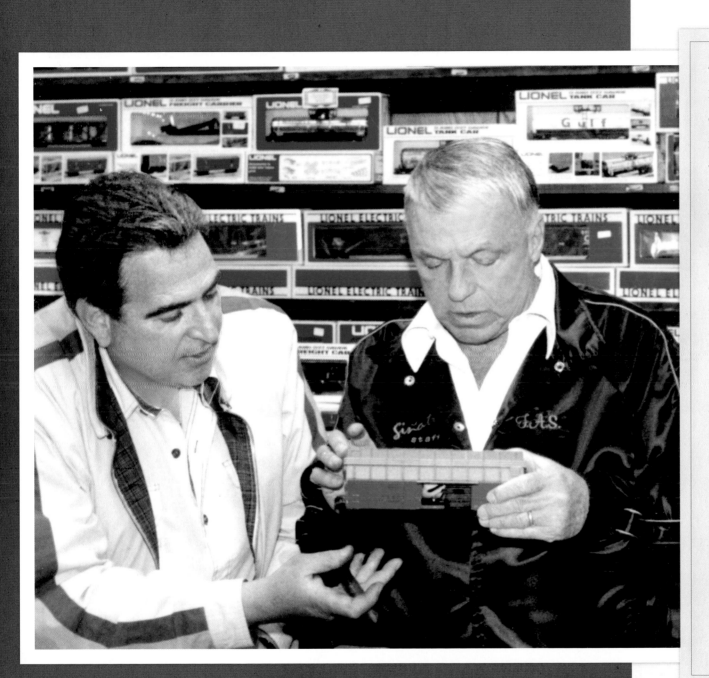

Hank Cattaneo and Sinatra inspect a model train in 1986.

"One of the joys of being on the road with Frank was sharing a common hobby, collecting old toy trains. In addition to being his production manager, one of my other roles was searching for local toy train stores in the various cities we traveled. The smaller the town, the smaller the store, the better. I would somehow find the time to visit, and if some exceptional trains or accessories caught my eye, I would buy them. Prior to performing, I would often meet Frank in his dressing room to discuss the venue, the setup, and answer any other questions he might have regarding the show. Eventually he would ask, "Hank, did you have a chance to find any train stores?" If I responded that I had, his face would light up and excitedly ask, "What did you get us?" I didn't care if the roof fell in on us after that, nothing could go wrong, we won! This picture was taken one Sunday afternoon in a small but delightful toy train store on the outskirts of Atlantic City, New Jersey. Jill, the owner of "The Train Store," was kind enough to stay open for us. Like kids in a candy store, we left with our arms loaded." –Hank Cattaneo

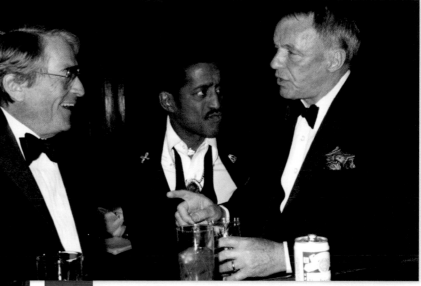

Gregory Peck, Sammy Davis Jr., and Frank share a drink and a laugh after attending a charity function.

The Sinatras celebrate Father's Day and granddaughter A.J.'s high school graduation at The Bistro in Beverly Hills, June 1991.

(far left) Author Charles Pignone and Frank Sinatra backstage at the Desert Inn, Las Vegas. "This was the closing night of the engagement; Frank Jr. took this photo." —Charles Pignone

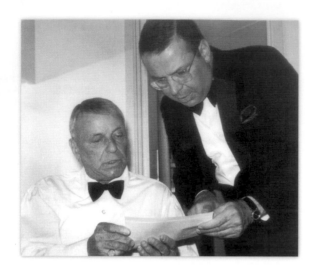

Sinatra and his son look over the song lineup backstage at the Royal Albert Hall, for a series of concerts in 1992.

(above) Sinatra Jr. was his father's musical director/conductor from 1988 to 1995. These concerts in 1992 would be the last time Sinatra performed in London.

"I promoted all of Frank's concerts in England beginning in 1962. London was one of Frank's favorite cities, and in turn, the audiences just idolized him. To the very end, with Frank it was always exciting. There will never be another performer of his caliber in our lifetime." –Harold Davison

(right) This photo was taken backstage before a concert at The Point in Dublin, Ireland, on October 9, 1991. Cattaneo would serve as a producer on Sinatra's *Duets* recordings.

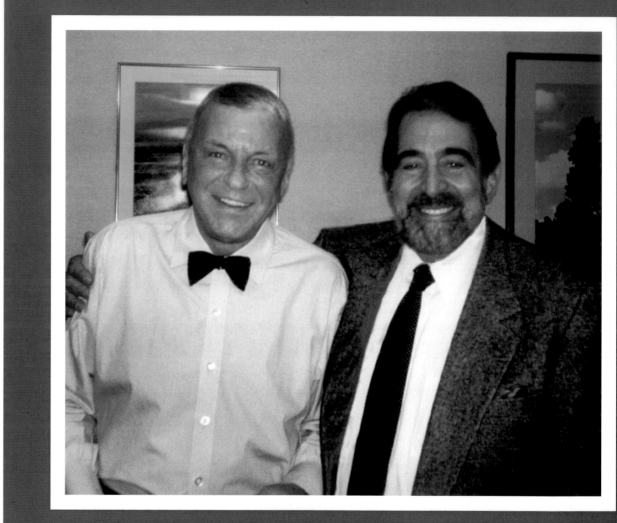

Frank with Hank Cattaneo, his tour production manager.

August 23, 1993, Frank, backstage at the Garden State Arts Center in Homdel, New Jersey, accepts a plaque from Columbia Record executives honoring the fiftieth anniversary of his first solo recording on the label. Long-time friend Frank Military, senior vice president of Warner-Chappel music, is on Frank's left.

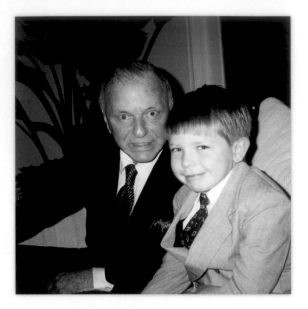

Frank with his grandson Michael
at a family function in the 1990s.

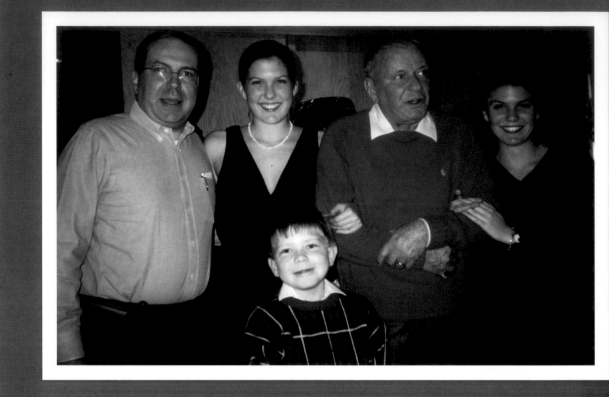

(right, top) Frank Sinatra with his three
grandchildren, Amanda, Michael, and A.J.
and son Frank, in 1994.

...

(right, bottom) Frank relaxes at his Palm
Springs home in 1990 surround by his dogs.
"My father loved dogs. He'd had as many as
eight at one time." —Nancy Sinatra Jr.

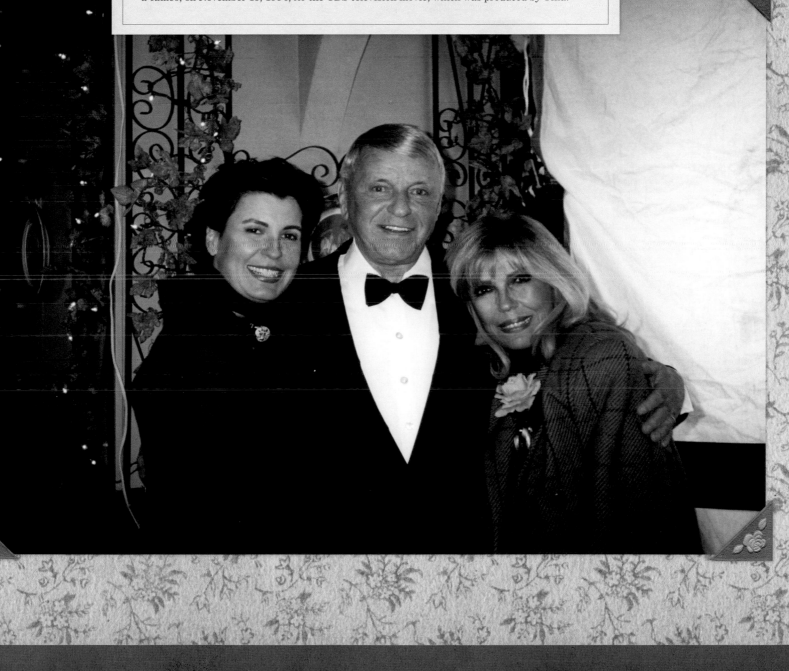

Tina, Frank, and Nancy Sinatra on the set of *Young At Heart* in Toronto, Canada. Sinatra filmed a cameo, on November 16, 1994, for the CBS television movie, which was produced by Tina.

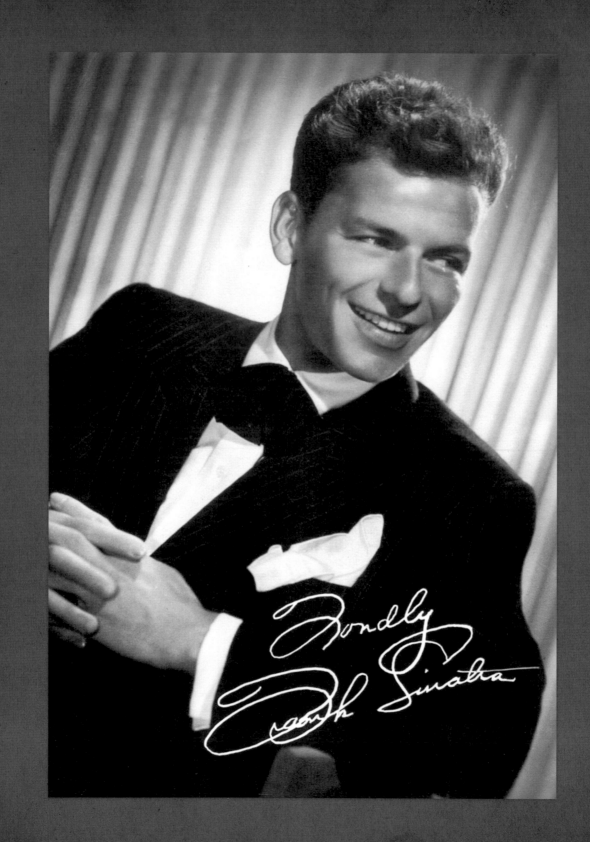

Fondly
Frank Sinatra

Image Credits

Every effort has been made to trace copyright holders. If any unintended omissions have been made, becker&mayer! would be pleased to add appropriate acknowledgment in future editions.

All photos are courtesy of The Sinatra Family Collection, except as noted:

 Courtesy of the Herman Rush Collection: Pages 31, 32, 33 (right)

 Courtesy of the Van Heusen Photo Archives: Pages 61, 64 (left), 84

 Courtesy of Hank Cattaneo: Pages 135, 138 (right)

 © 1978 Bob Willoughby / MPTV.net: Page 3

 © 1987 Gunther / MPTV.net: Page 128 (right)

Acknowledgments

With special thanks to the following:

The Sinatra family: Nancy Sr., Nancy Jr., Frank Jr., Tina, A.J. Lambert, and Amanda Erlinger for their trust, support, and dedication in preserving the legacy of Frank Sinatra.

Bob Finkelstein, for his patience and guidance through the years.

Tony Bennett, Nathan 'Sonny' Golden, Angie Dickinson, Quincy Jones, Tom Dreesen, Joe Soldo, Harold Davison, Hank Cattaneo, Herman Rush, Brook Babcock, Glenna Viola, Keith Barrows, Bill Moynihan, Kat Adibi, Rique Uresti, and Dede Merrill.

Bill Miller, Billy May, and Al Viola, generous friends who passed away before the completion of this book.

At becker&mayer!, president Andy Mayer, image researcher Shayna Ian, and editor Brian Arundel. Thanks also to designers Joanna Price and Todd Bates, and senior production coordinator Leah Finger.

At Little, Brown, executive editor Michael Sand and editorial assistant Julia Novitch for their belief and support of this book.